IMAGES
of America

THE JICARILLA
APACHE OF DULCE

IMAGES
of America

THE JICARILLA APACHE OF DULCE

Veronica E. Velarde Tiller, PhD,
and Mary M. Velarde

ARCADIA
PUBLISHING

Published by Arcadia Publishing
Charleston, South Carolina

Printed in the United States of America

Library of Congress Control Number: 2011943817

For all general information, please contact Arcadia Publishing:
Telephone 843-853-2070
Fax 843-853-0044
E-mail sales@arcadiapublishing.com
For customer service and orders:
Toll-Free 1-888-313-2665

Visit us on the Internet at www.arcadiapublishing.com

*This book is dedicated to all who ever photographed
the Jicarilla Apache people and Mary Polanco, editor
of the* Jicarilla Chieftain *for three decades.*

CONTENTS

ACKNOWLEDGMENTS

Our gratitude and appreciation go out to many people without whom this volume would not have been possible. Two tribal members were key in obtaining photographs: Sherryl Vigil, superintendent of the Jicarilla Agency, and Levi Pesata, president of the Jicarilla Apache Nation. Without their cooperation and understanding of the value of preserving our tribal history, we would not have the quality and quantity of photographs for this book.

We owe thanks to Shane Valdez and Cougar Vigil of the *Jicarilla Chieftain* office for their excellent cooperation—a special thanks goes to Cougar Vigil for going the extra distance for us. So many individuals helped us in different capacities, and we acknowledge them. They are Gifford Velarde, Cherrise Quintana, Joanna Dykehouse, Jeffrey Blythe, Dorothy Velarde, Loyola Bird, Kenneth Bird, Frieda Havens, Bryan Vigil, Jay Vigil, Alberta Velarde, Everett and Roberta Serafin, Viola M. Vicenti, Ingeborg Vicenti, Bernice Muskrat, Rogene and Leona Garambulla, Ina Montoya, David Velarde Jr., Jackson Velarde, Melissa Polaco, Peggy Nez, Virginia Johnson, Verinda Reval, Claudia Vigil-Muniz, Darren Vigil Gray, Sherrie Quintana, Carson Vicenti, Carey Vicenti, Bobbie Nell Velarde, Andrea Hernandez-Holm, Brian Ramirez, Tom Watts, Debora Loretto, Nina Zentz, Bob Horne Photography, Ardala N. Velarde, Cris Velarde, Ethel Muniz, David C. Harrison, Nancy Hunter Warren, Kenneth DeDios Jr., Reba June Serafin, and Bob C. Velarde.

We especially thank the following institutions for the use of their photographic collections: the Division of Anthropology and the History Library of the American Museum of Natural History of New York; the Palace of the Governors Photo Archives (NMHM/DCA); the Mathers Museum of World Cultures at Indiana University; Braun Research Library at the Autry National Center; the Denver Museum of Nature and Science; the Colorado Railroad Museum; the Dulce High School Library; the National Archives; Smithsonian Institution's Anthropological Archives; the New Mexico State Fair; the Jicarilla Game and Fish Department; the Bureau of Indian Affairs (BIA), Jicarilla Apache Agency; and the *Jicarilla Chieftain*. The Jicarilla Apache Planning Office is also thanked for the use of its map.

INTRODUCTION

Moving from "the sacred center of the earth" where the Great Spirit had created the aboriginal homelands of the Jicarilla Apache to a remote, isolated, and mountainous Indian reservation in Northern New Mexico during 1887 was almost more than the people could bear. Yet, out of this seemingly hostile and barren environment, the Jicarilla Apache built a new homeland that is the epicenter of their modern existence. Since time immemorial, the aboriginal territory of the Jicarilla Apache has been northeastern New Mexico, southeastern Colorado, and the plains area of western Texas and Oklahoma. It was within these boundaries that the Jicarilla lived prior to the arrival of the Spanish in the 16th century.

Over two centuries, the Spanish gradually moved their settlements onto Jicarilla lands, bringing with them horses, livestock, and trade goods that eventually became the medium of intercultural exchange. By the middle of the 18th century, the Jicarilla lands were well settled by Spanish villages, thus accommodating the influx of American settlers who came from the east by way of the Santa Fe Trail. Eventually, the Jicarilla became homeless people in the midst of their homelands, and by default, their lands officially became a part of the United States in 1846. The invasion of Jicarilla homelands led to conflict and war in 1854 and 1855. The defeat of the Apache in the southwest meant relocating them onto Indian reservations. The permanent 416,000-acre Jicarilla Apache Indian Reservation was created on February 11, 1887, by executive order. Several Indian reservations were established for the Jicarilla prior to 1887 in various parts of New Mexico Territory, but the US government was never successful in moving the Jicarilla to these reservations and out of their beloved and sacred homelands.

A whole new way of life began for the Jicarilla Apache when they were resettled on the 1887 reservation. Over the next 50 years, they literally built a new way of life from scratch. When the Army-escorted wagons arrived on the reservation, there were but a few shanties beside a railroad track that served as a point of contact to issue food rations to the Jicarillas. Looking in all directions, one would see nothing but barren country. In this bleak environment, the Apache were expected to become farmers and assimilate into the dominant society through education and Christianity, as mandated by the General Allotment Act that was passed by Congress that same year. This act initiated a new federal Indian policy that required all Indian reservation lands be allotted into 160-acre parcels that were to become the private property of the Indian landowners. This ill-conceived land policy was dead on arrival. With its short growing season, scarcity of reliable water resources, and harsh winters, the reservation high country, at an average altitude of 7,500 feet, was not farming country. The allotments meant nothing to the Apache as they scattered their homes over the 416,000 acres according to their traditional and extended family units. The idea of allotted lands was alien and foreign to their concept of landownership: that it could not be owned by any one person and that the land belonged to the entire tribe in

common. From 1887 to about 1900, to any visitor to the reservation, the Apache were invisible, because they pitched their tipis and Army-style canvas tents in the canyons, valleys, and foothills within close proximity to bodies of water.

The allotment process proceeded during the 1890s with dire and comic consequences. Most of the Jicarilla heads of family did not have full Spanish or Anglo names, so the allotting agents wrote down poorly translated Apache names on the allotments. The agency personnel changed so frequently that no one knew what allotment belonged to whom. Although less than one-third of all the allotments were issued, the majority of those remained unidentified.

A vast stand of ponderosa pine covered over 230,000 acres of the reservation. This great natural resource became the foundation of the Apache economy, although timber cutting was not a part of the government's allotment plan. The allotment mix-up affected the timber logging for almost 30 years. Despite changes to timber laws governing Jicarilla lands, the status of allotted and unallotted lands affected what timber lands could and could not be sold. The Jicarilla leaders made a very important decision that greatly influenced how their economy and livelihood would be affected for years to come. The people agreed that all proceeds from timber, irrespective of the status of the land, would be deposited into a common fund that would benefit all tribal members.

It was soon clear to several Jicarilla agents that advocating agricultural pursuits for the Apache people was not supportable, considering the land and climate. One action taken by the government to recognize that farming was not feasible was adding another 300,000 acres of land to the south of the reservation with the executive orders of 1907 and 1908. The Apache people, by and large, were still living in tents, tipis, and crowded, small, one-room log cabins that reflected their poverty, despite the vast timber resources and the readily available sawmills. Selling the timber and using the revenues to purchase sheep and cattle provided the answer for Jicarilla economic development. Timber cutting began around 1910. Livestock was purchased and issued to all heads of families, thus building another tier to the economic foundation based on timber.

From the 1920s to the 1960s, livestock was the economic mainstay of the Jicarilla reservation. Almost overnight, the economic situation turned around for the Apache. Taking care of sheep proved to be compatible with the Apache lifestyle, living out in the country with plenty of grazing lands, but most of all, having the opportunity to work for themselves made a huge difference in their lives. The sheep herds increased almost tenfold by 1930, causing an increase in their personal income. Consequently, they had better health, and children were back in school.

By the 1920s, the Dutch Reform Church was established and entered into an agreement with the federal government to take over the education of the Apache children. The infamous Mission School was the boarding school all children attended. It was modeled after other industrial boarding schools throughout the United States where trade and industry were emphasized as opposed to academics.

From 1887 to about 1930, education was not a priority for the government. A handful of Jicarilla children attended the off-reservation boarding schools at Fort Lewis in Colorado and the Santa Fe Industrial Boarding School in Santa Fe. A local government school for the Jicarilla children was not built in Dulce until 1903. By this time, several generations of Apache had become adults without the benefit of any formal schooling. The school was poorly managed. Children were expected to attend school half a day and work at the school in various capacities to help in its operation. By 1912, tuberculosis and influenza had spread so rapidly through the student population that the mortality rates went sky high. The dire health conditions, if not immediately addressed, meant the demise of the Jicarilla as a people within the next few decades. To restore the health of the children, the school had to be closed down and converted into a tuberculosis sanatorium. This incident sealed the fate of education for many decades, as parents were reluctant to send their children to school and education made little sense for the people.

With the passage of the Indian Reorganization Act of 1934, the allotment policies ended, inaugurating a new era for the Jicarilla Apache. In 1937, the Jicarilla voted to accept a tribal constitution and bylaws. The reservation was divided into 11 voting districts along the lines of traditional family settlements. The new tribal council, consisting of 18 Apache leaders, passed

a resolution changing the status of the land from private allotments to full tribal ownership. Families were allowed to keep their land assignments based on beneficial use; that is, they could keep it as long as they were making use of it. The Emmet Wirt Trading Post was purchased and became a cooperative store to accommodate the livestock owners.

During World War II, young Jicarilla men joined the armed forces, reflecting the rise in the educational level of the school population. A new boarding school campus was built, replacing the Mission School. The sanatorium was closed as the health of the children improved. The livestock owners were at the height of their income earnings as their sheep and cattle were shipped to help supply the troops overseas. It was during the war years that the Jicarilla made the greatest progress in improving their economic situation. With an increase in personal income, they modernized their homes and ranches and purchased trucks, farm equipment, and more livestock. This era saw the Jicarilla as truly economically self-sufficient and on the road to improvement in other areas of their lives. Without the stigma and pressure to become like their non-Indian neighbors, Apache culture was openly and proudly practiced. More resources made community-based ceremonials, like puberty feasts and the Bear Dance, more affordable.

The decline of the livestock industry began after the war. Its fate was sealed by the drought of the early 1950s and the discovery of oil and gas on the southern part of the reservation. By the late 1960s, a mass population movement to Dulce began in search of tribal and governmental jobs. This demographic shift made Dulce no longer just an agency town but the headquarters of the Jicarilla Apache tribal government. In 1968, the constitution was revised to create a three-branch government modeled on the US government. Council members were elected on an at-large basis, eliminating the district system. This decade also saw the end of the government boarding school in favor of a state-operated public school.

Since the 1970s, Dulce has grown to a modern town with all the characteristics that describe a small, modern New Mexico town. The enormous economic success of the Jicarilla Apache Tribe is tied to Dulce, where the tribe has become a leading regional economic force based on its vast oil and gas resources, its timber resources, its eco-recreational industries, and its enterprises. In the 1980s and 1990s, the tribe purchased approximately 100,000 acres of land off the reservation to increase its land base to the current figure of 879,917 acres. Linked to its economic success is its off-reservation ownership of properties in Florida, Wyoming, and the Lodge at Chama, a world-class hunting lodge that hosts celebrities, sport figures, and serious big game hunters. In these decades, it saw the end to many of its legal actions taken against the federal government for the mismanagement of its water and natural resources and national oil and gas companies for the under payment of royalties. Along with its economic achievement, it has also contributed to federal Indian policies and laws, like the 1981 US Supreme Court *Merrion* case, which gave Indian tribes the right to tax energy companies doing business on Indian reservations.

In 1987, the Jicarilla Apache Tribe celebrated the centennial year of the establishment of its 1887 reservation. This celebration initiated a new trend in recognizing tribal accomplishments and achievements. Every year on the week of February 11, the tribe celebrates its cultural heritage. The *Jicarilla Chieftain*, the tribal newspaper, is replete with stories recognizing past and current achievements of its members. There are countless unsung heroes among the Jicarilla people—from those who worked untold hours to make their ranches successful to the young men who served in the US armed forces to those who blazed the way in education, those who served in tribal government and its administration, those who never compromised their traditional culture to keep it alive, and those who preserved and promoted the traditional and modern arts, dance, and music.

In 1995, the Jicarilla Apache Tribe officially changed its name to the Jicarilla Apache Nation. According to the US Census of 2000, the Jicarilla Apache had 3,403 tribal members, a total labor force of 1,666, and a high school graduation rate of 78 percent. Those with a bachelor's degree or higher level of education total 14 percent. The most promising beacon on the eve of the 21st century was the revitalization of Jicarilla Apache culture and language as a tribal priority. In the new century, the growth of the Jicarilla Apache Nation will continue as it experiences even more social and economic successes.

No community was ever built or grew without people who were dedicated to its growth and well-being. The Jicarilla and Dulce are no exception. The establishment of the reservation required the support of a powerful alliance that included Gen. Nelson A. Miles, New Mexico territorial governor Edmund G. Ross, Commissioner of Indian Affairs J.D. Atkins, and Colorado senator Henry M. Teller. They all played powerful roles in the political pro- and anti-forces behind the establishment of the reservation during the 1880s. Joining this distinguished group were the founders of the 1887 Jicarilla Apache Reservation: the Jicarilla Apache leaders of the 1880s, including Huerito Mundo, Augustine Vigil, Juan Julian, San Pablo, and Santiago Largo, who had the courage and foresight to fight for the establishment of the current reservation.

Early agency foresters and Indian agents, like Supt. Chester E. Faris in the 1920s and Commissioner of Indian Affairs John Collier, who initiated the Indian Reorganization of 1934, made a monumental difference for the Jicarilla people and their economy. In the modern period, it was progressive programs like the establishment of the higher education fund, the minors' trust fund, and the Jicarilla Family Plan of the 1960s that moved Jicarilla families more comfortably into the American mainstream. It was the hiring of the Nordhaus Law Firm of Albuquerque in 1970 that made the Jicarillas wealthier in the 1980s and 1990s with the firm's expertise in Indian claims and timber accounting work, water rights law, oil and gas law, and investment law.

The Jicarilla people have always been of interest to the American people. The world-renowned photographer Edward S. Curtis made Chief James Garfield Velarde famous by including him in his 1905–1910 North American Indian photographic series. Linguist-anthropologist Pliny Goddard photographed the Jicarilla in 1909 while collecting Apache cultural items for the American Museum of Natural History of New York City. Photographer Joseph C. Dixon travelled to Dulce in 1913 with the Wanamaker Expedition and captured Jicarilla life of that year. Not as notable or well known are the missionaries, like Gertrude Van Roekel, who preserved Jicarilla history through her photographs of the 1930s to 1940s, and government agents who left hundreds of images in the agency records. Like these photographers who have left an indelible record of Jicarilla life, this book hopes to maintain the American public's interest in the Jicarilla Apache through the pictorial history of the tribe and Dulce, New Mexico, from 1887 to 2000.

One

EARLY YEARS
1887 TO 1933

Access to the Denver & Rio Grande Railroad, which ran through the reservation from Lumberton along the Amargo Creek to Pagosa Junction and on to southwestern Colorado, was the main reason the site was selected to become the Jicarilla Apache Agency, which became known as Dulce. Dulce means "sweet" in Spanish and is pronounced *loosi* in the Jicarilla Apache language. Unlike other New Mexico towns, Dulce was created as an administrative center for the federal government to carry out its policies of assimilation. Over the years, the tribal town grew to include schools, a church, a hospital, a trading post, a sawmill, stockyards, and residential houses.

In this mountain wilderness, the agency became the focal point of everything associated with the Jicarilla and was the contact point between them and the rest of the world. With the exception of the agency site, there was nothing but wagon and horse trails leading out of Dulce to scattered Apache encampments. The Apache, only a generation removed from their native lands, had no reliable means of income and lived off government-issued food rations and the few jobs provided by the booming timber industry. A handful of families had herds of sheep and goats. By the 1920s, the Jicarilla Agency and the Emmet Wirt Trading Post become the iconic symbols for the town of Dulce. With government support, the Dutch Reform Church had taken over the education of the Jicarilla children. These institutions were charged with transforming the Jicarilla Apache, who were now livestock owners, into members of the dominant society. Isolation from the major towns, villages, and transportation routes hindered the process of initiating the Jicarilla into a new lifestyle. For the Jicarilla Apache, the remote location was a blessing in disguise, as they were able to maintain their language, religion, and customs despite the efforts of the government. In 1934, the Jicarilla Apache were ready for the next era of great prosperity and progress.

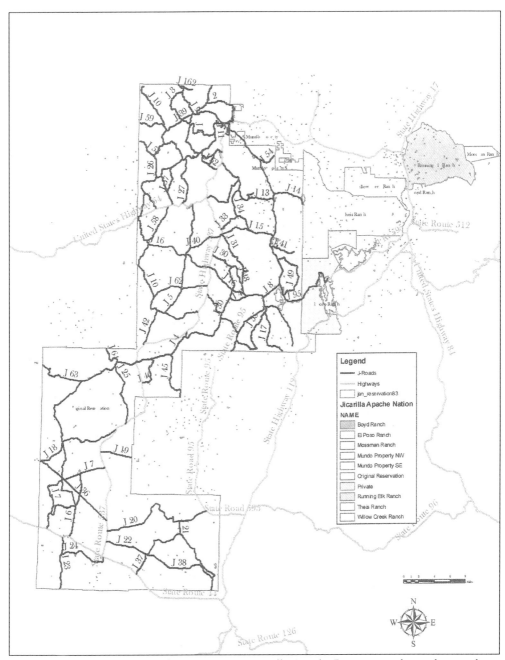

This map shows the growth of the 416,000-acre Jicarilla Apache Reservation, located in northern New Mexico, from its establishment by the executive order of February 11, 1887. In 1907, three hundred thousand acres were added. From the 1970s to the 1990s, the Theis, El Poso, Willow Creek, and Gomez Ranches and Chama Land were purchased by the tribe. Today, the reservation consists of 879,917 acres. (Courtesy of Jicarilla Apache Planning Office, Jicarilla Apache Nation.)

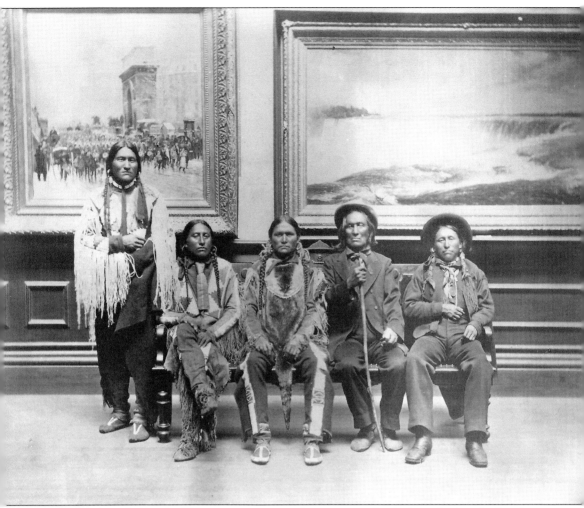

In 1874, 1880, and 1884, the US government created reservations for the Jicarilla Apache, but for various reasons, they were abrogated and returned to the public domain by the US Congress. In 1884, the Jicarilla were removed to the Mescalero Apache Reservation in southern New Mexico, but the Jicarilla leaders fought to get this reservation back. In 1887, after returning home from Mescalero, the Jicarilla Apache finally had a permanent home. The Jicarilla Apache Llanero and Ollero chiefs and clan leaders are shown in this photograph taken at the Corcoran Gallery in Washington, DC, in 1880: from left to right are Santiago Largo, Huerito Mundo, Augustine Vigil, San Pablo, and Juan Julian. Their wisdom, courage, and foresight ensured that the Jicarilla Apache have a reservation. It is to these leaders, who are the founders of the 1887 reservation, that the Jicarilla Apache owe eternal gratitude. Today, all Jicarilla Apache are related in some way to these leaders. (Courtesy of Smithsonian Institution, National Anthropological Archives.)

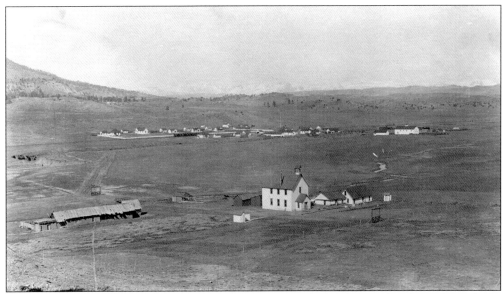

This rare 1909 photograph of the Jicarilla Agency site and school was taken by anthropologist Pliny E. Goddard of the American Museum of Natural History when he visited the Jicarilla Reservation, collecting artifacts and taking photographs for the Bureau of Ethnology. In the far background are the Colorado Rocky Mountains, and the eastern slope of Archuleta Mountain is to the left. (Courtesy of the Division of Anthropology, American Museum of Natural History.)

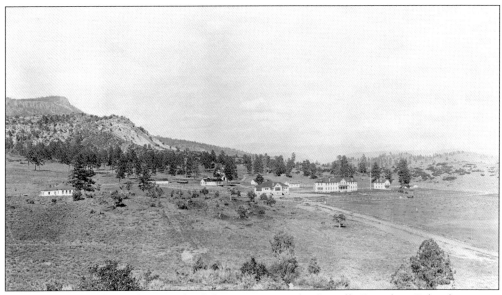

This 1909 image shows that north of the agency was the Jicarilla Boarding School campus, constructed in 1902. The two-story building on the right was the dormitory that housed 125 boys and girls. The building to the far left was the school hospital, built in 1905. Within a decade, the dormitory was converted to a tuberculosis sanatorium for the student population. (Courtesy of the Division of Anthropology, American Museum of Natural History.)

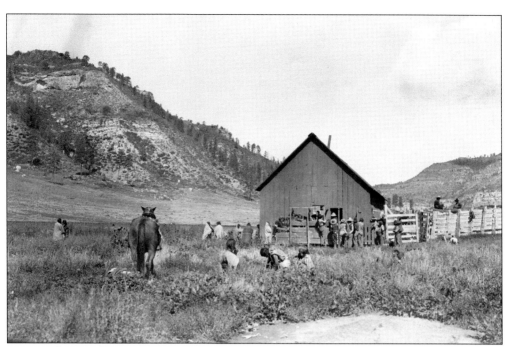

In 1909, the Jicarilla Apache were living mostly off of the government food rations. Just southwest of the agency and railroad tracks was the slaughterhouse from which beef was issued to the Jicarilla Apache. (Courtesy of the Division of Anthropology, American Museum of Natural History.)

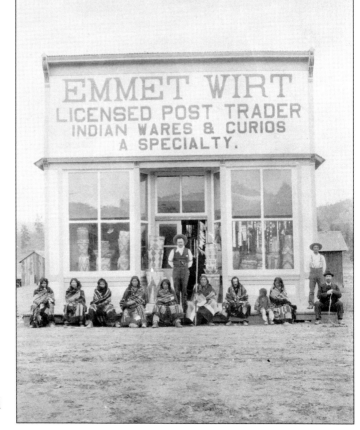

This photograph of the Wirt Trading Post was taken between the 1890s and the 1920s. (Courtesy of Braun Research Library Collection, Autry National Center, N.20754.)

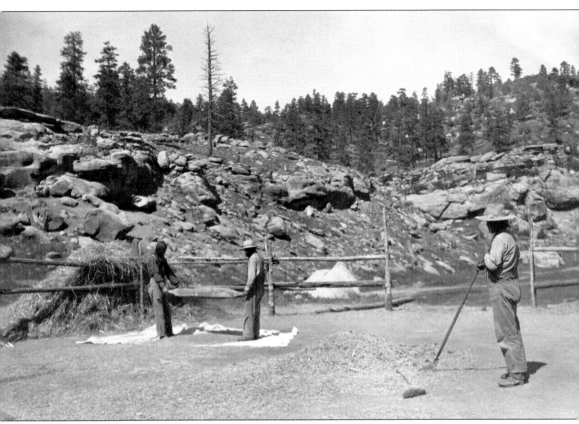

Making farmers out of the Jicarilla Apache was the primary goal of federal Indian policy of assimilation. This policy was mandated by the General Allotment Act of 1887, commonly known as the Dawes Act. While it was not totally successful, there were many Jicarillas who farmed on various but limited parts of the reservation. On September 23, 1909, Pliny Goddard captured this image of John Chopra, who is standing on the right, holding the pitchfork, with two other unidentified Apache helpers, who are standing to the left, sifting grain on the threshing floor. The photograph was taken near Dulce. (Courtesy of the Division of Anthropology, American Museum of Natural History.)

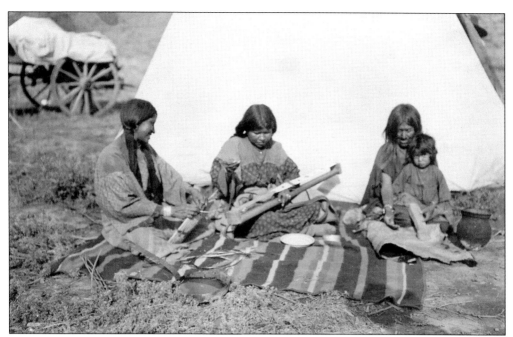

Long before the Jicarilla were placed on the reservation, the women made baskets for which they became famous and for which the Jicarilla were named. In Spanish, the word *jicarilla* means basket maker. In the photograph above, Mrs. Reuben Springer, his mother, and his sister-in-law are making baskets, preparing clay for pots, and beading beside their tipi. Below, Mrs. Springer and her daughter standing next to their tipi, the standard mode of Apache housing in 1909. Women and girls preferred to wear shawls and blankets instead of coats and jackets, which did not become popular until several decades later. (Both, courtesy of the Division of Anthropology, American Museum of Natural History.)

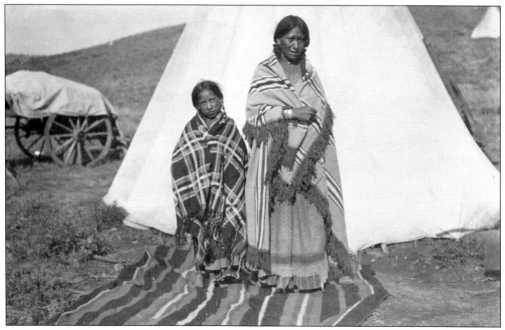

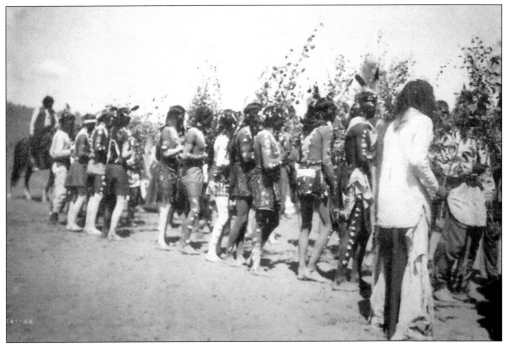

The Jicarilla continued their rich ceremonial life after relocating to the 1887 reservation. The ceremonial relay runners are lined up on the east-west racetrack either before or after the race that takes place at Stone Lake every September 15, no matter what day the 15th falls on. (Courtesy of BIA, Jicarilla Agency.)

In this Goddard photograph, the Llanero and Ollero clans dance as they come together on the Goijiya racetrack on September 15, 1909. Goijiya is a public event and is the only tribal ceremonial event where taking photographs is allowed, thus there are no photographs of the other sacred ceremonies. (Courtesy of the Division of Anthropology, American Museum of Natural History.)

Posing for Goddard in this photograph, taken on September 15, 1909, are, from left to right, the Llanero runner, Jicarilla Agency superintendent John Williams, and the Ollero runner. (Courtesy of the Division of Anthropology, American Museum of Natural History.)

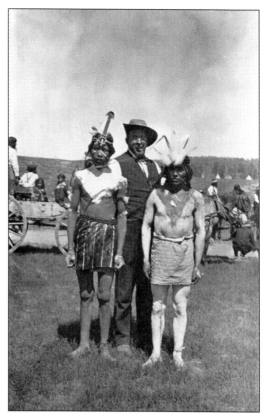

Everyone rode horses at Goijiya. This image shows three unidentified teenage girls wearing their festive native dresses at Goijiya and having fun riding their horses. (Courtesy of National Archives.)

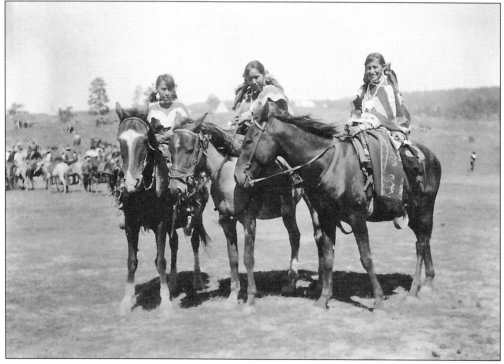

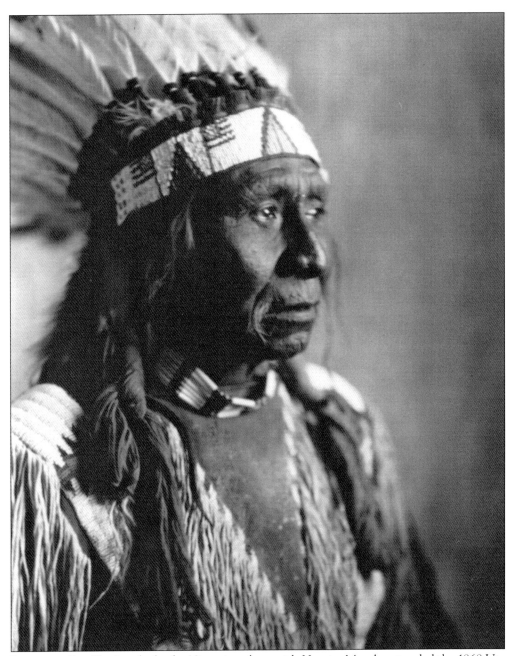

Prominent Jicarilla Apache leader Vicentito, along with Huerito Mundo, attended the 1868 Ute Treaty negotiations when the issue of a Jicarilla reservation was also addressed. For unknown reasons, Vicentito did not attend the 1880 meeting in Washington, DC. This portrait of him was captured during the Wanamaker Expedition in 1913. (Courtesy of American Museum of Natural History Library.)

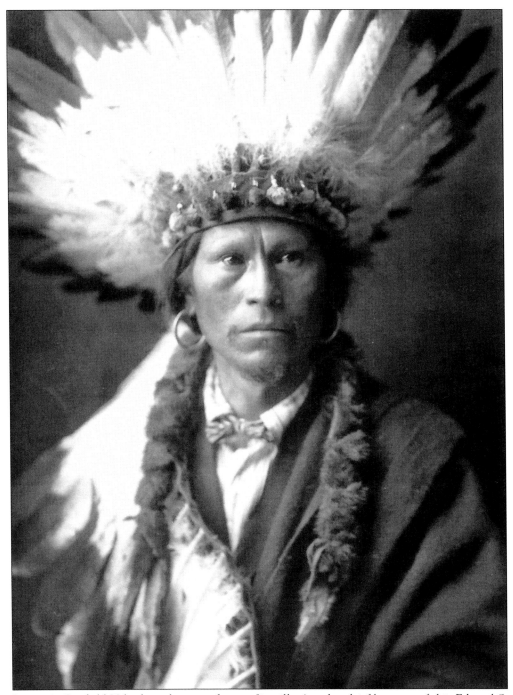

James A. Garfield Velarde is the most famous Jicarilla Apache chief because of this Edward S. Curtis photograph, taken between 1905 and 1910. Today, his image is found on book covers, advertisements, Native American memorabilia, and a mural at the Colorado Historical Museum in Denver. He succeeded his brother Huerito Mundo as chief of the Olleros in 1886. (Courtesy of Smithsonian Institution, National Anthropological Archives.)

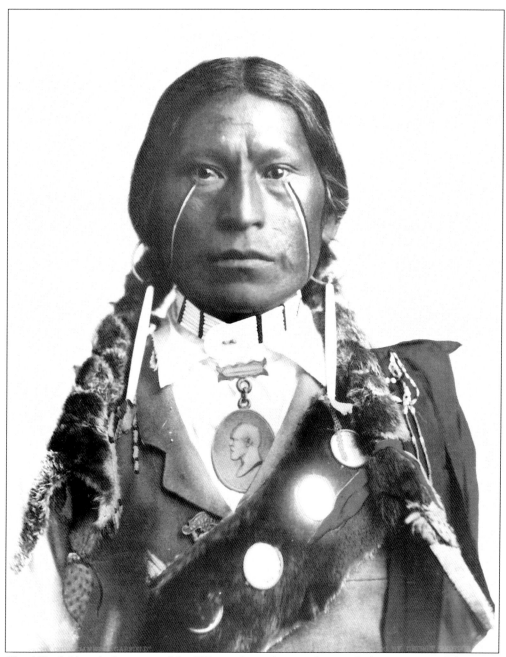

Chief Garfield took the name of the US president who gave him an Indian peace medal in 1884 and, later on, the surname of Velarde. This photograph is as famous as the one taken by Edward S. Curtis. It is used on books, textbooks, and educational guides on Native Americans. Garfield moved with his people from Jicarilla native lands to the 1887 reservation. He lived to about the age of 106 and had a farm and ranch in La Jara. (Courtesy of Smithsonian Institution, National Anthropological Archives.)

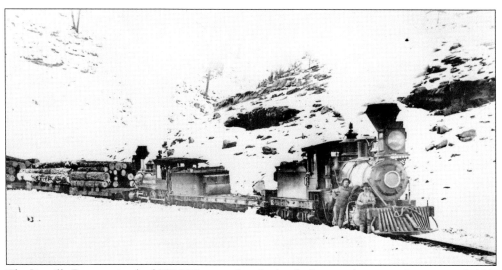

The Jicarilla Reservation had 232,000 acres of timberlands. Logging began in the winter of 1908. Several railroad spurs were connected to the main Denver & Rio Grande Railway, including the two locomotives in this photograph. They were owned by the Biggs and Burns-Biggs Lumber Companies. (Courtesy of Colorado Railroad Museum Collection.)

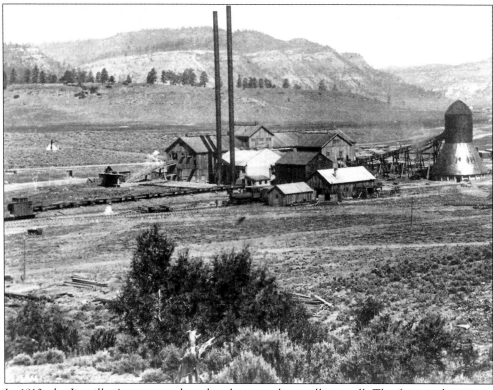

In 1910, the Jicarilla Agency purchased and operated a small sawmill. The first products were railroad ties that were sold to the Rio Grande & Southwestern Railroad. A few Jicarillas had jobs at this sawmill. (Courtesy of BIA, Jicarilla Agency.)

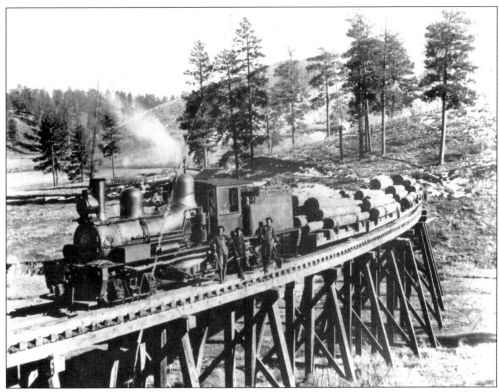

The Shay locomotive was used by the railroad companies on the reservation to haul loads up steep grades. The Shay locomotive in this photograph is hauling four loads of logs. It was sold to the Pagosa Lumber Company in Dulce in 1918. It took the private sector to get the reservation economy off the ground. (Courtesy of Colorado Railroad Museum Collection.)

The timber industry covered a wide area of the reservation, and several railroad spurs from nearby towns ran through the reservation. This 1920 photograph shows employed Apache loggers Elargio Notsinnah, left, and Frank Largo at the sawmill camp at El Vado, New Mexico. (Courtesy of BIA, Jicarilla Agency.)

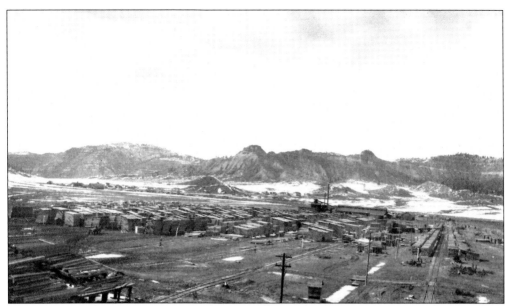

The Pagosa Lumber Company operated its sawmill in Dulce from 1916 to 1924 and in the Burns and Wirt Canyons from 1925 to 1926. In 1925, this company harvested over 15.5 million board feet of timber and paid the tribe over $55,000. This revenue was used to purchase more livestock for the Jicarilla. (Courtesy of BIA, Jicarilla Agency.)

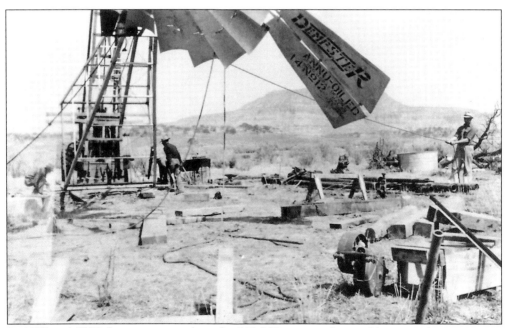

In 1907 and 1908, by executive orders, the 300,000-acre southern addition to the reservation was made to accommodate the livestock industry. The climate in the area was milder, so Jicarilla livestock owners wintered their stock there. In this photograph, BIA workers are installing a windmill to provide water for the stock. (Courtesy of BIA, Jicarilla Agency.)

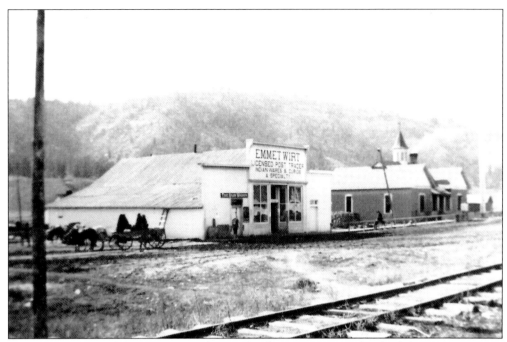

This 1919 photograph by W.H. Ritter depicts the three institutions that had the greatest impact on the development of the reservation economy prior to 1934: the Emmet Wirt Trading Post, Jicarilla Agency, and the Denver & Rio Grande Railway. (Courtesy of Colorado Railroad Museum Collection.)

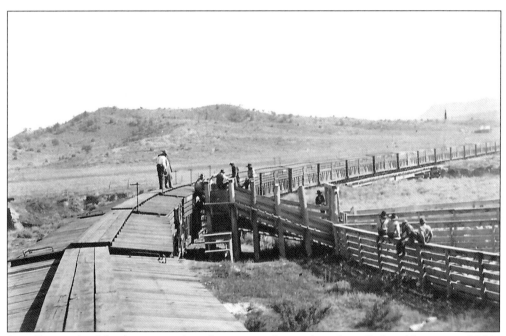

Jicarilla men load lambs onto railway boxcars at the stockyards in Dulce. (Courtesy of BIA, Jicarilla Agency.)

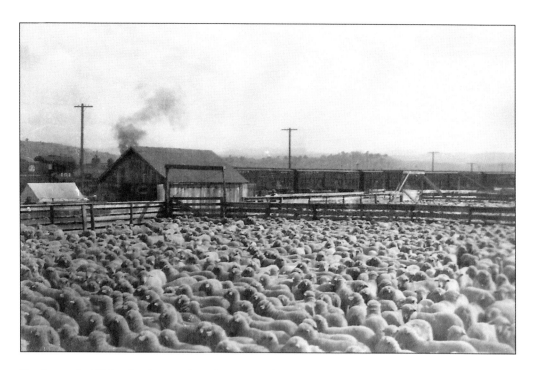

By the early 1930s, the livestock industry was booming and striving. The photograph above shows the large herds that were brought to the Dulce stockyards for shipping via the railroad. The image below provides a wider east-to-west view of the stockyards, with the agency visible in the far background. (Both, courtesy of BIA, Jicarilla Agency.)

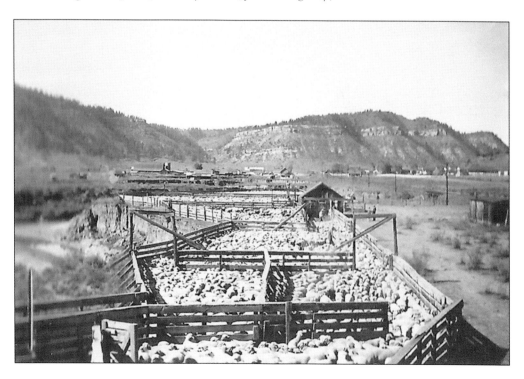

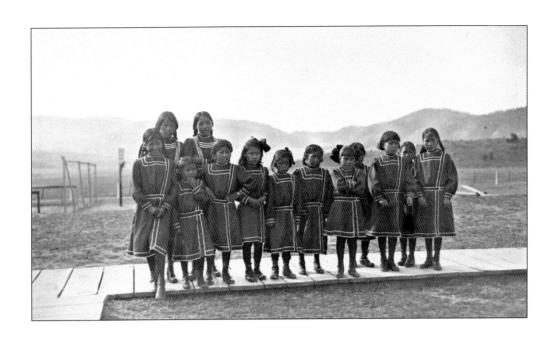

Wearing uniforms was a standard practice at Indian boarding schools, as depicted in these two 1913 images captured by Joseph K. Dixon during the Wanamaker Expedition to Dulce. In the above photograph, young Jicarilla girls are dressed up to attend the event. Pictured below, students gather to watch their visitors make a flag presentation behind the school building. (Both, courtesy of Mathers Museum of World Cultures, Indiana University.)

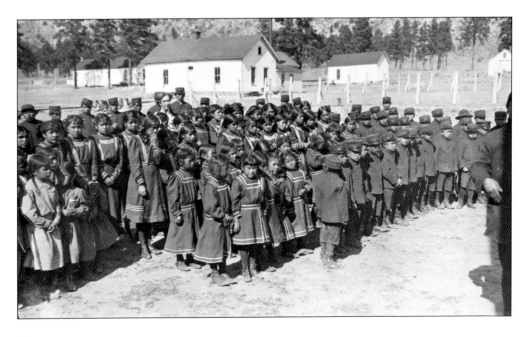

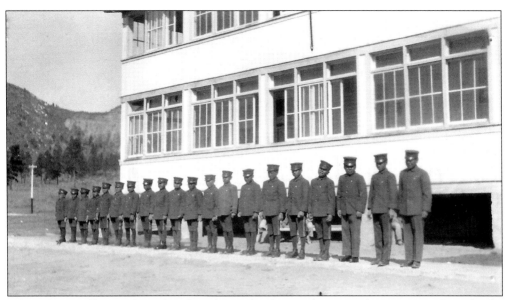

When the Jicarilla Apache Indian Boarding School opened in 1903, there was great hope for the education of the Jicarilla children. In this photograph, the boys are dressed like military cadets, reflecting the strict and regimental training at the school. (Courtesy of BIA, Jicarilla Agency.)

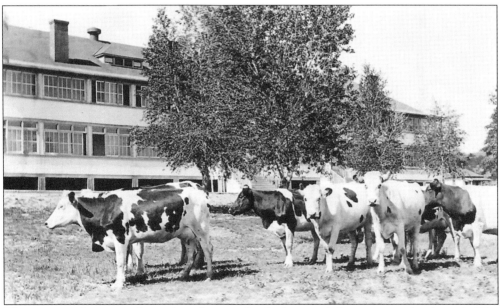

The vocational program focused on farming for the boys and domestic arts for the girls. The children studied academic subjects for half of the school day and spent the other half carrying out chores like cooking, housekeeping, and working at the laundry and the farm to help operate the school. The dairy herd wandered on the school grounds, as seen in this photograph. (Courtesy of BIA, Jicarilla Agency.)

Due to the high rate of tuberculosis among the students, the Jicarilla Boarding School closed in 1918. In 1921, the government entered into an agreement with the Dutch Reform Church to take over the education of the children. The campus consisted of the church, the Mission School, and employee quarters north of the agency and south of the sanatorium. (Photograph by Gertrude Van Roekel, courtesy of Dorothy Velarde.)

The Dutch Reform Church in Dulce was established in 1914 and became a powerful agent of social change on the reservation, as well as an advocate for the people. The church provided some of the few community social events and recreational activities in Dulce. During Christmas, the church gave out presents to all tribal members, which was greatly appreciated. (Photograph by Gertrude Van Roekel, courtesy of Dorothy Velarde.)

It was rare for Jicarilla Apache students to graduate from high school prior to the 1940s. One of the few Jicarilla students who graduated from Sherman Institute (an Indian boarding school) of Riverside, California, in the early 1920s was Norman TeCube. He became the official interpreter for the agency superintendent and, later, for the tribal councils. (Courtesy of Viola M. Vicenti.)

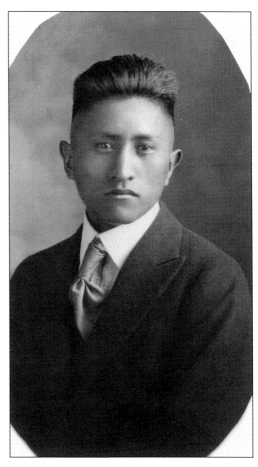

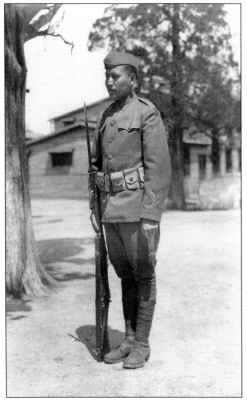

Few Jicarilla Apache served in World War I. One of the few Jicarilla young men who served in the US Army was Juan Quintana. He is pictured here in 1919 at Camp Dixon, New Jersey. Quintana served over 20 years in the Army. (Courtesy of Mathers Museum of World Cultures, Indiana University.)

31

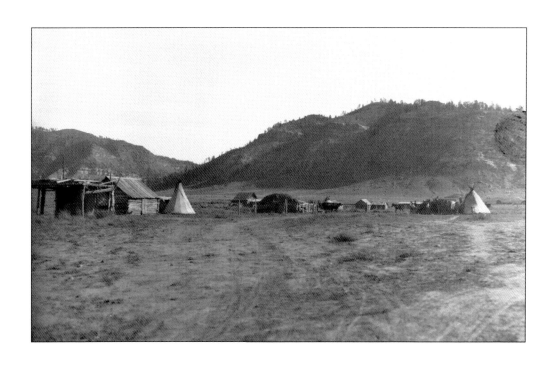

In 1913, the official photographer for the Wanamaker Expedition, Joseph K. Dixon, simply captioned these two photographs as "Homes of the Jicarilla Apache." (Both, courtesy of Mathers Museum of World Cultures, Indiana University.)

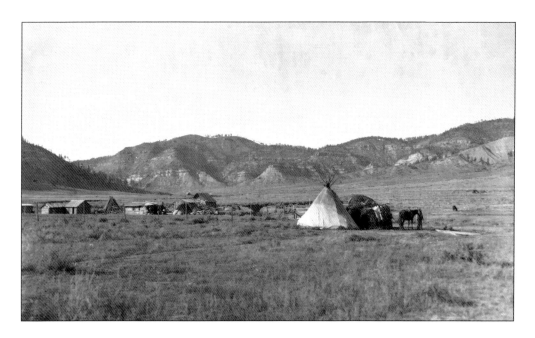

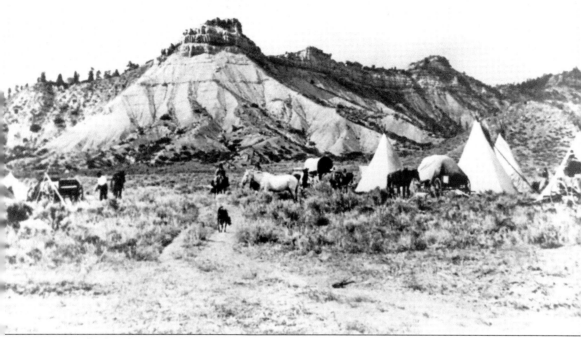

Few Jicarilla families actually made their homes in Dulce during the early years of settlement. Most preferred to live far out on the reservation. This photograph depicts Jicarilla tipis and tents under Dulce Rock, located just northwest of the agency in an area where some Jicarilla families have lived since the 1890s. (Courtesy of Jicarilla Apache Cultural Center.)

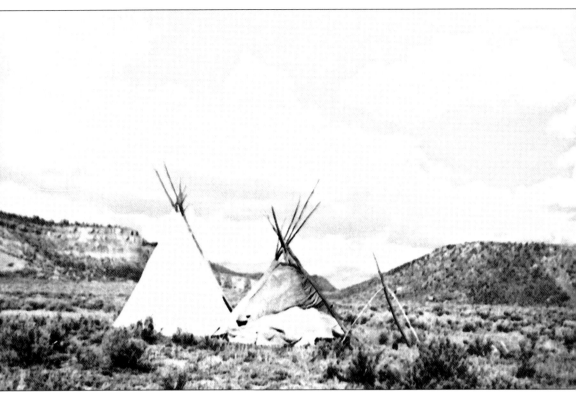

This 1930s photograph from the Museum of New Mexico was captioned "Jicarilla Apache camp." The two tipis are located in a field in Dulce across the valley from the Indian boarding school campus and across the railroad tracks. Today, this area has an old airport runway and a baseball field. (Courtesy of Palace of the Governors Photo Archives [NMHM/DCA], neg. no. 40786.)

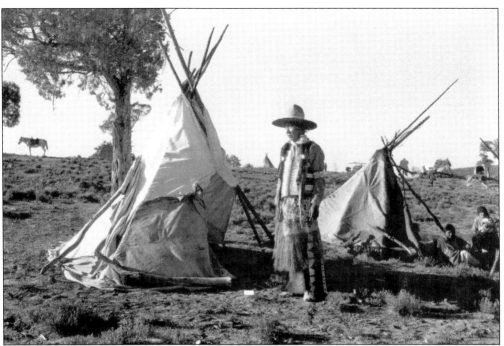

Photographer T. Harmon Parkhurst took this photograph in the 1930s at the Goijiya Feast at Stone Lake. He captioned it, "Man in front of two teepees at feast." (Courtesy of Palace of the Governors Photo Archives [NMHM/DCA], neg. no. 22673.)

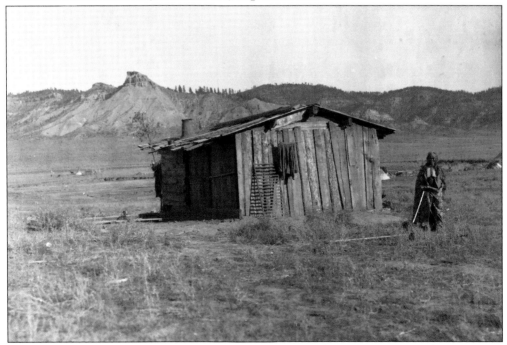

This photograph of a lone Jicarilla cabin with a person standing next to it was taken by Joseph K. Dixon during the 1913 Wanamaker Expedition when it came through Dulce. (Courtesy of Mathers Museum of World Cultures, Indiana University.)

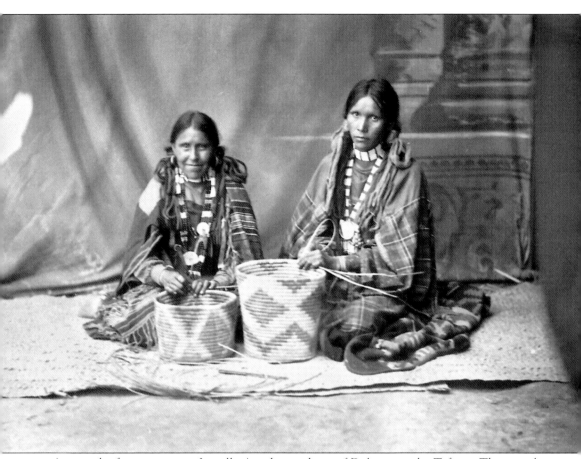

Among the first permanent Jicarilla Apache residents of Dulce were the Tafoyas. This popular photograph shows Darcia Tafoya, left, and an unidentified woman weaving baskets at the 1904 World's Fair in St. Louis, Missouri. Proximity to the agency and their expertise as basketmakers were possibly the reasons for this unique travel opportunity to represent their tribe. (Courtesy of Smithsonian Institution, National Anthropological Archives.)

Two

SETTLING IN
1934 TO 1959

The Great Depression came and went without much notice by the Jicarilla Apache people. Despite the Depression, their standard of living increased, creating a pervasive air of prosperity and happiness. By the 1930s, raising livestock was second nature to them as their herds multiplied. Optimism rose when the New Deal Congress passed the Indian Reorganization Act of 1934 (IRA), which ended the allotment policies and created the Indian Division of the Civilian Conservation Corps (CCC-ID). It provided public works jobs for the Jicarilla, like building and repairing dams, roads, and fences and conducting natural resource conservation work.

The IRA was written for the Jicarilla who desired greater affluence and halcyon days. The Jicarilla people accepted an IRA tribal constitution and bylaws on August 4, 1937. This constitution recognized self-government, reinforced the communal ownership of the entire land base and its natural resources, and outlined a specific economic development plan. One of the first actions of the 18-member council was to incorporate under the name of the Jicarilla Apache Tribe. With a loan from the IRA's revolving loan fund, the tribe purchased the Wirt Trading Post and renamed it the Jicarilla Apache Cooperative Store.

World War II saw a demand for agricultural products and rising profits for the Jicarilla ranchers, but that was not all that was rising. The 1940s witnessed the increase of students attending high school. Patriotism rose to new heights as young Jicarilla men that had the educational qualifications joined the armed forces. Supporting them was the council, who purchased $1 million in war bonds. Regrettably, after the war, prices dropped and began the decline of the livestock industry.

In 1958, the Jicarilla Apache Indian Boarding School closed its doors when the State of New Mexico took over the academic portion of the education of Jicarilla children. When oil and gas were discovered on the southern addition of the reservation in 1952, a higher education scholarship and a minor's trust fund were established. Like the IRA, this windfall brought in new wealth that created a new way of life in the coming decades.

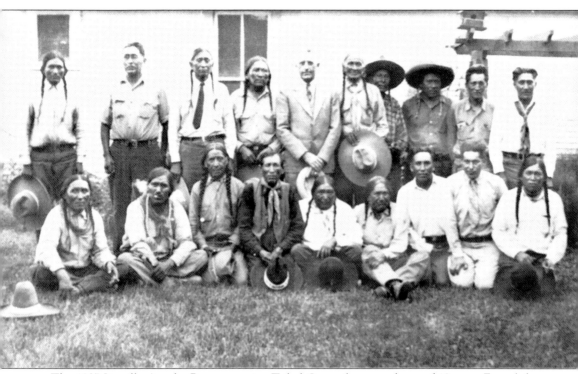

The 1937 Jicarilla Apache Representative Tribal Council was made up of 18 men. From left to right are (first row) Agapito Baltazar, Ramon Tafoya, Sixto Atole, Albert Velarde Sr., Grover Vigil, John Mills Baltazar Sr., Laell Vicenti, Henry "Buster" Vicenti, and Lindo Vigil; (second row) Antonio Veneno, Cevero Caramillo, Dotayo Veneno, Juan Vigil, agency superintendent A.E. Stover, DeJesus Campos Serafin, Garfield Velarde Sr., Anastacio Julian, Norman TeCube, and Jack Ladd Vicenti. (Courtesy of BIA, Jicarilla Agency.)

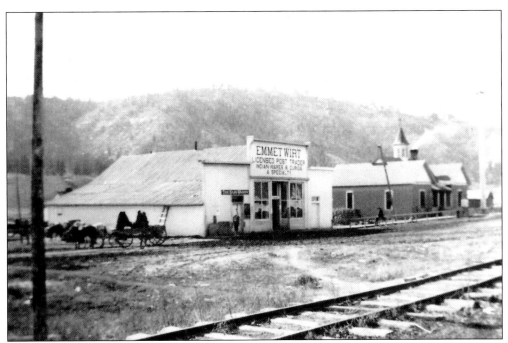

One of the first actions of the new council was to take out a federal charter. On September 4, 1937, the Jicarilla became a federal corporation under the name of the Jicarilla Apache Tribe. It also took out an $85,000 loan under the IRA's revolving credit fund and purchased the Wirt Trading Post, renaming it the Jicarilla Apache Cooperative Store. (Courtesy of BIA, Jicarilla Agency.)

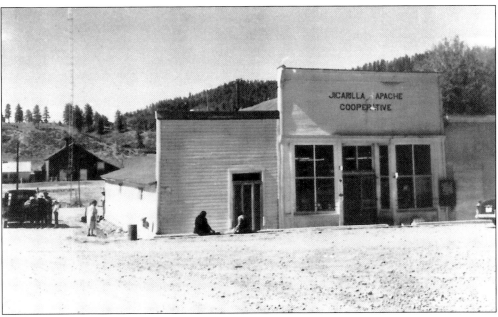

Note that in this photograph, the sign on the top of the store that formerly read "Emmet Wirt Trading Post" now reads "Jicarilla Apache Cooperative." (Courtesy of Dulce High School Library.)

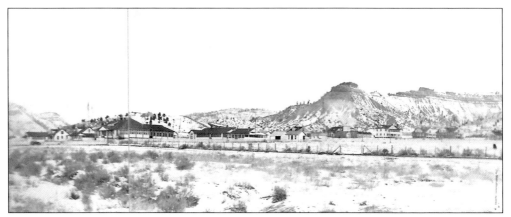

Facing west and north from the railroad tracks, this BIA agency photograph from the mid-1930s shows, from left to right, the public school, a teacher's cottage, a nurse's cottage, a hospital building, a morgue, an orphanage, and a lab cottage. This group of buildings is located right under Dulce Rock. (Courtesy of BIA, Jicarilla Agency.)

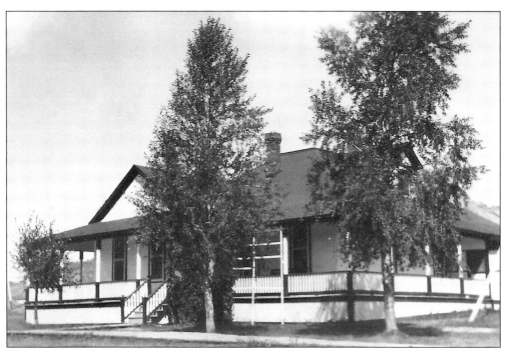

The superintendent's house was the biggest residential home in Dulce in the 1930s. It was located across from the agency and Wirt's Trading Post. It was restored in the 1990s and now houses the Jicarilla Apache Cultural Center. (Courtesy of BIA, Jicarilla Agency.)

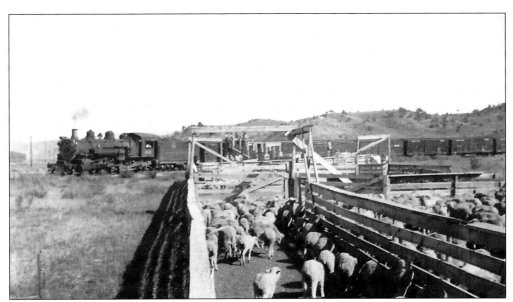

Next to the Dulce stockyards two railroad tracks met. One was the main Denver & Rio Grande Railroad, and the other, seen in this photograph, was a railway spur that hauled timber from the interior regions of the reservation. (Courtesy of BIA, Jicarilla Agency.)

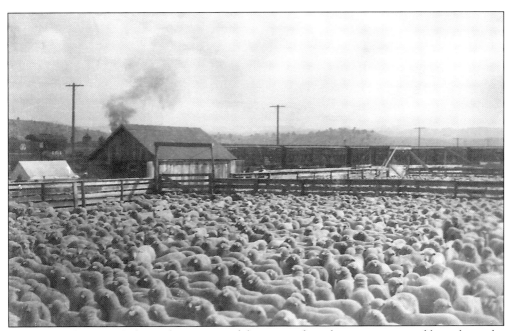

This 1930s photograph shows the amount of sheep raised on the reservation and brought to the Dulce stockyards for shipment to markets. (Courtesy of BIA, Jicarilla Agency.)

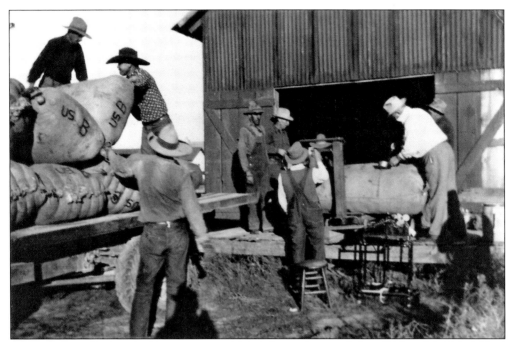

The 1937 Jicarilla Apache Representative Tribal Council created the Old People's Tribal Herd to help care for the elderly who were unable to take care of their herds. Agency workers and Jicarilla men pictured here unload bales of wool from the tribal herd for shipment. (Courtesy of National Archives.)

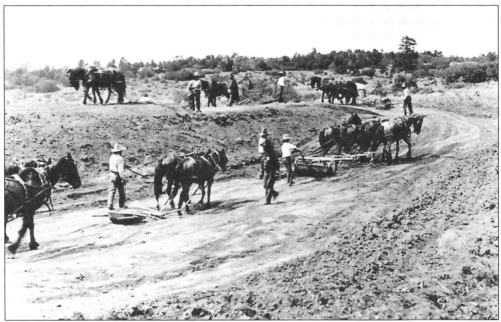

During the 1930s, the Civilian Conservation Corps (CCC), a New Deal program, operated a division for Indian tribes commonly known as the CCC–Indian Division (ID). Public works projects like roads, dams, and bridges were constructed and repaired. In this photograph, Jicarilla crews build one of many dams constructed during this era. (Courtesy of National Archives.)

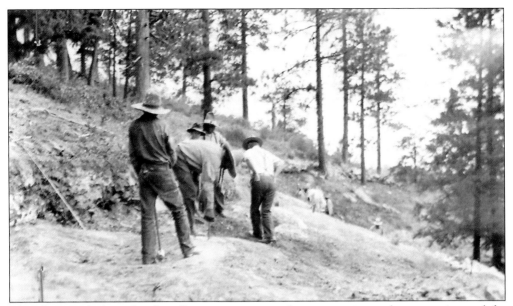

This photograph shows four Jicarilla men carrying out forest protection and conservation work for the forest division of the agency. The CCC-ID provided training and many jobs on the reservation during the Great Depression years. (Courtesy BIA, Jicarilla Agency.)

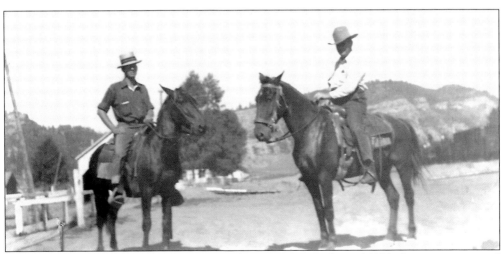

Horses were still a means of transportation on the reservation in the mid-1930s for agency personnel to carry out their jobs. In this image, senior forest ranger M.J. Osborn is on the horse to the left, and C.L. Graves is on the right. (Courtesy of BIA, Jicarilla Agency.)

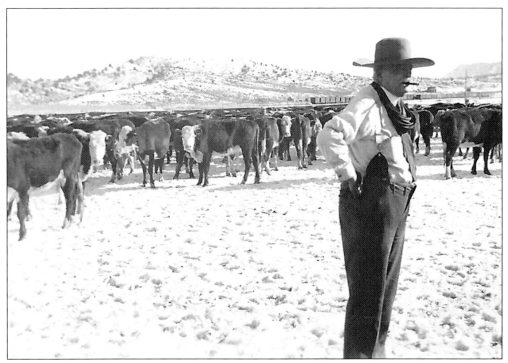

Shown in this 1930s photograph is Emmet Wirt, owner of the Wirt Trading Post, standing in front of a herd of Hereford cattle in a field near the Dulce stockyards. Note the train in the far background. (Courtesy of BIA, Jicarilla Agency.)

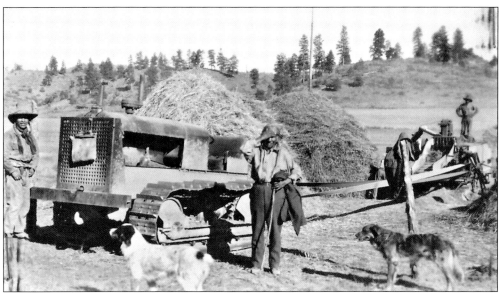

Farming activities mainly supported the livestock industry. In this photograph, hay is harvested on Campos DeJesus Serafin's land in La Juita Canyon, southwest of Dulce Lake. Serafin is the man standing between the two dogs. In the far background on the right is his son Theodore. The other two men (one is partially hidden by the coat on the post) are unidentified. (Courtesy BIA, Jicarilla Agency.)

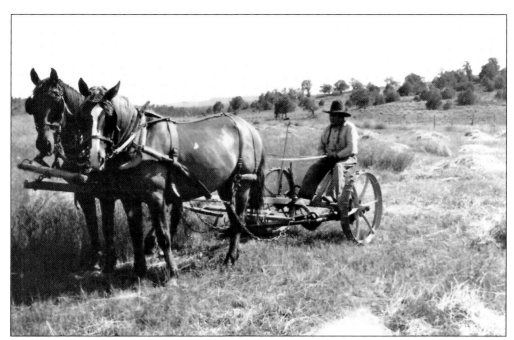

Grover Vigil bails hay on his farm at La Jara. (Courtesy of National Archives.)

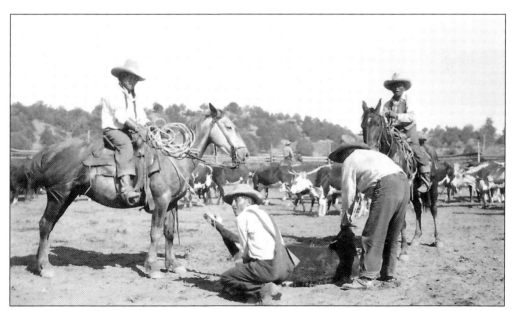

The majority of the Jicarilla livestock operators owned sheep, but many preferred cattle ranching, like the Vigil family, who had a ranch at Stinking Lake. (Courtesy of BIA, Jicarilla Agency.)

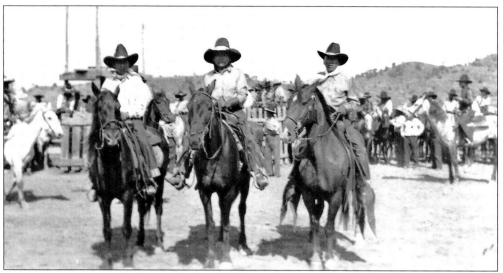

In this 1940s photograph, three Apache cowboy ropers pose at the Fourth of July Rodeo in Dulce. Rodeo became a favor sport among the Jicarilla. (Courtesy of National Archives.)

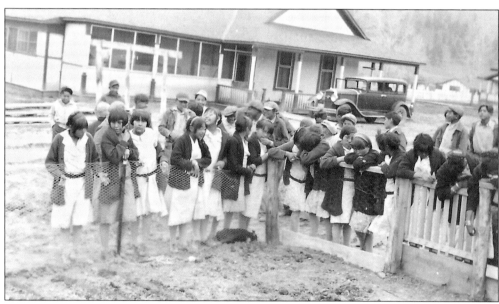

Jicarilla teenage girls attend a 4-H gardening class offered by the agency extension office. (Courtesy of BIA, Jicarilla Agency.)

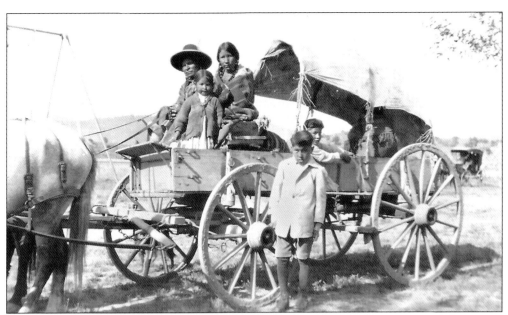

This photograph reflects Jicarilla life in the early 1900s. Transportation was mainly horse and wagon. It is possible that the young boy, who is wearing a school uniform, was either being delivered to or picked up from the Mission School by his parents. (Courtesy BIA, Jicarilla Agency.)

Juan Monarco and his wife, Juana, have arrived with their wagon and team of horses to pick up their children from the Mission School. They are parked next to the lodge at the Mission School campus, where families from the southern end of the reservation stayed when they come to Dulce. (Courtesy of Dorothy Velarde.)

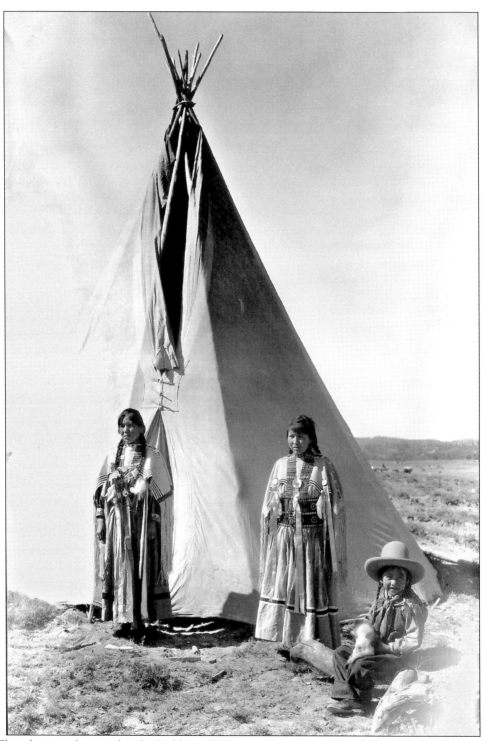

This photograph was taken by Parkhurst T. Harmon between 1925 and 1945. His caption reads "Jicarilla Apache women and children in front of tipi." (Courtesy of Palace of the Governors Photo Archives [NMHM/DCA], neg. no. 2076.)

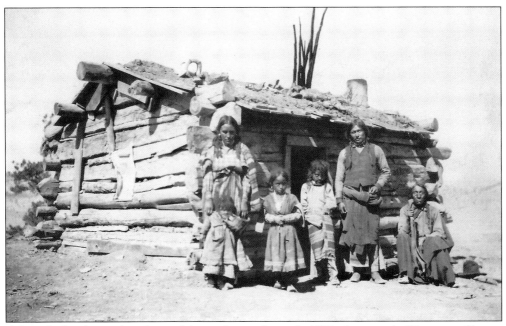

A Jicarilla family stands in front of their cabin in this early 1930s photograph. (Courtesy of Image Archives, Denver Museum of Nature and Science.)

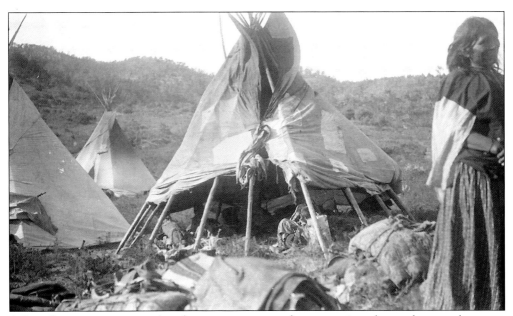

A Jicarilla woman was at an Apache encampment on the reservation when a photographer came by and captured this image of her. (Courtesy of Palace of the Governors Photo Archives [NMHM/DCA], neg. no. 21553.)

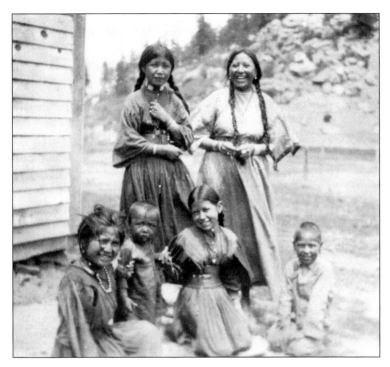

In this 1940s photograph, Jicarilla women and children were dressed and possibly ready to go to town. The woman standing on the left is Edith Serafin. The other woman and children are unidentified. (Courtesy of Images Archives, Denver Museum of Nature and Science.)

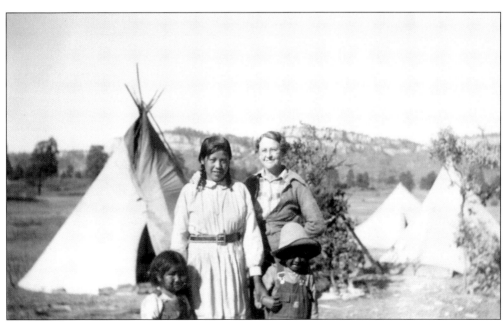

This 1940s photograph was taken at the Atole family summer camp at Hillcrest. The adults in this image, from left to right, are Katherine Atole and a woman from the Mission. The children are unidentified, but the one with the hat may be Leonard Atole. (Courtesy of Image Archives, Denver Museum of Nature and Science.)

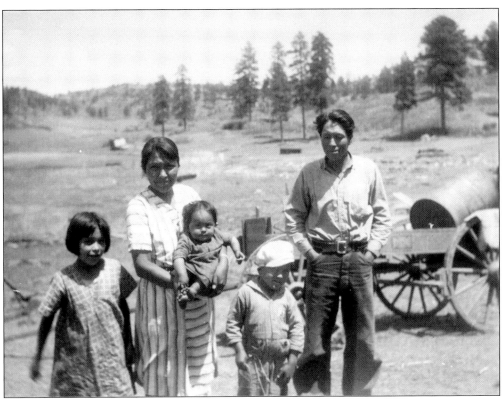

On a visit by one of the missionaries from the Dutch Reform Church, the Dan Vigil family posed for this photograph at their home at La Jara Canyon. Standing left to right are Julia, Alice (holding her baby Esther), Wallace, and Dan. (Courtesy of Image Archives, Denver Museum of Nature and Science.)

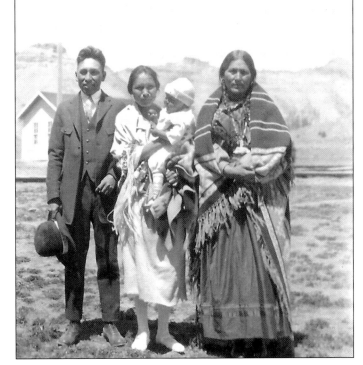

This 1930s photograph was taken in Dulce. Standing from left to right are Laell Vicenti, his wife, Emma (holding their infant son George Lesley), and Mrs. Grover Vigil. (Courtesy of BIA, Jicarilla Agency.)

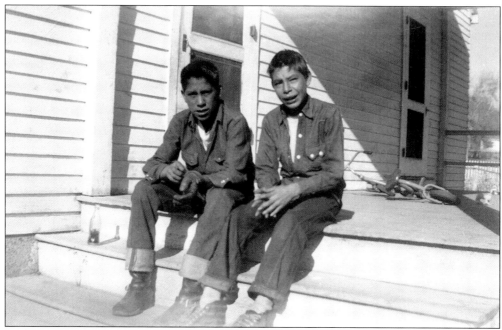

In this 1930s image, Clement Monarco (left) and Ernest Martinez sit on the steps of the boys' dormitory at the Mission School. (Courtesy of Viola M. Vicenti.)

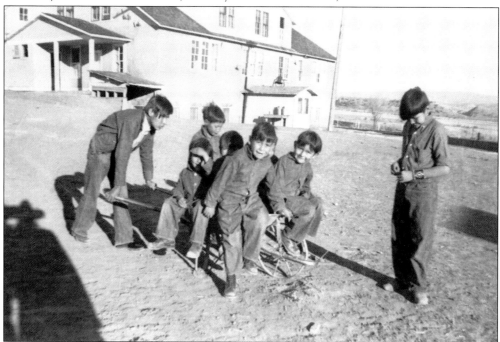

This 1938 photograph shows seven young boys playing on a wheelbarrow near the Mission School's boys dormitory. From left to right are Phillip Pansy (holding the handles of the wheelbarrow), Ernest Martinez (standing behind the two unidentified boys seated in the back of the wheelbarrow), Victor Baltazar (sitting in the front of the wheelbarrow), and Taylor Monarco (sitting above the front wheel). Standing on the far right is Phillip Vigil. (Courtesy of Dorothy Velarde.)

Playing on the porch of the boys' dormitory at the Mission School are two youngsters, Taylor Monarco (left) and Howard Vigil. (Courtesy of Dorothy Velarde.)

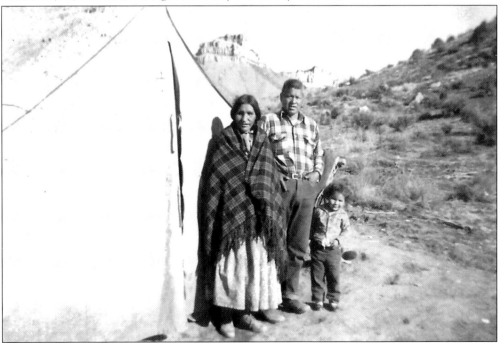

Hans TeCube, his wife, Senida, and their son are shown in this 1958 photograph next to their tent near Dulce Rock. In his later years, TeCube became a medicine man, and he is credited with reviving the Bear Dance in the 1960s. (Courtesy of Viola M. Vicenti.)

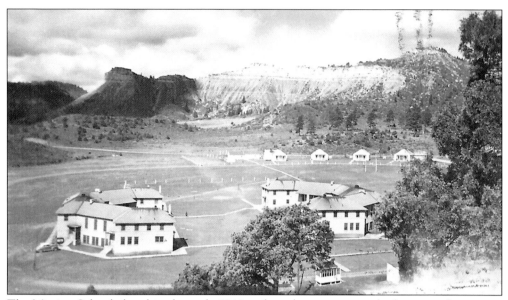

The Mission School closed in the early 1940s, when the government built a pair of two-story dormitories to accommodate the growing student population. These dormitories were located south of the old sanatorium, also known as the Annex. The new dormitories were later called Damstra and Faris Halls. (Courtesy of Dorothy Velarde.)

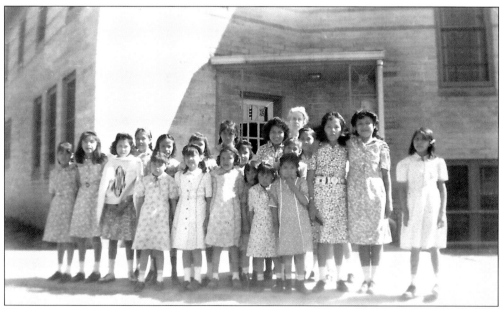

This photograph was taken on June 22, 1947, by an unidentified photographer. It features young girls, who are all wearing similar dresses, standing in front of the girls' dormitory with a woman who must be a dorm matron. (Courtesy of Rogene Garambulla.)

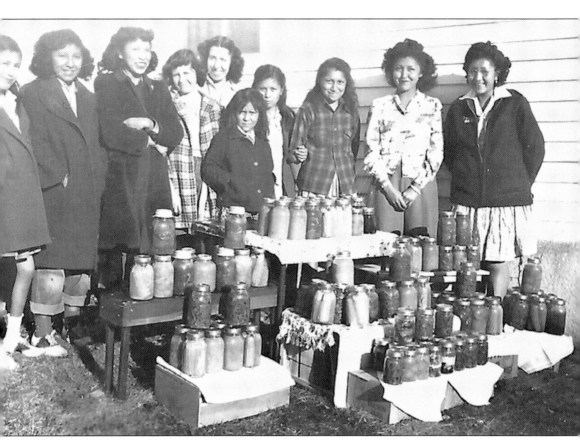

The Jicarilla Apache Indian Boarding School allowed its students to attend community 4-H classes. In this 1940s photograph, 10 girls are posing in front of their canning jars. They are from, left to right, Nina Vicenti, Adala Naranjo, Alberta Vicenti, an unidentified girl, Norma Henry, Violet Vicenti, Charlotte Cachucha, Winona Ladd Vicenti, Ethel Baltazar, and Eloise Baltazar. (Courtesy of Rogene Garambulla.)

Jicarilla Apache Indian Boarding School students were required to attend church services. Dressed for church and standing from left to right are Andrew Lovato, Jackson Velarde, Malcolm Largo, and Wallace Julian. (Courtesy of Roberta Serafin.)

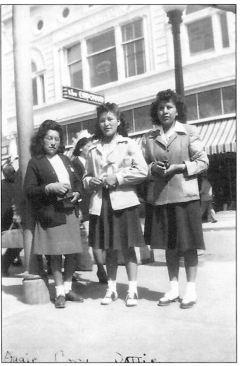

Pictured from left to right are Agnes Vigil, Cora Vigil, and Dorothy Monarco, who were shopping in downtown Santa Fe. During the 1940s, when Jicarilla students reached high school, there was not a school in Dulce for them to continue their education, so many students went to off-reservation boarding schools like Santa Fe Indian School. (Courtesy of Dorothy Velarde.)

One Jicarilla high school graduate from the 1940s was Ella Mae Maria. In this photograph, Ella has just graduated from the Santa Fe Indian School. (Courtesy of Dorothy Velarde.)

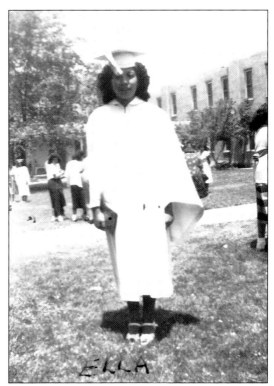

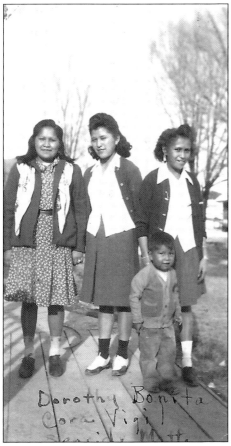

Dorothy Bonita (left), Cora Vigil (center), Senida Vigil (right), and Matthew Vigil are on the sidewalk at the Dutch Reform Church campus. (Courtesy of Dorothy Velarde.)

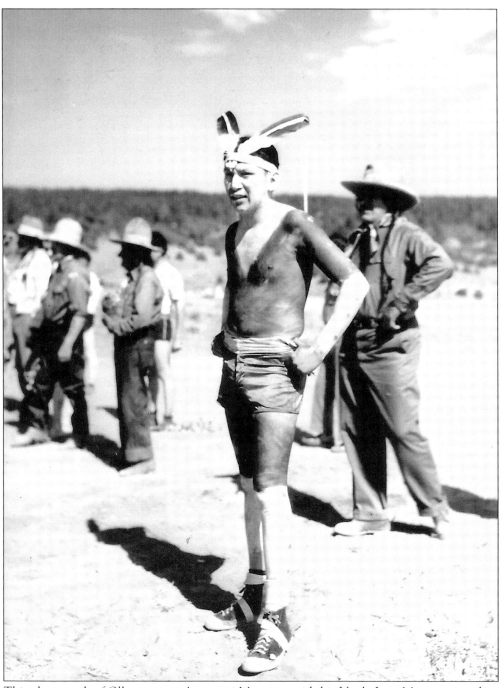

This photograph of Ollero runner Amaranti Monarco, with his Uncle Juan Monarco standing directly behind him, was taken in September 1948 at Goijiya by photographer Ralph P. Anderson. (Courtesy of Palace of the Governors Photo Archives [NMHM/DCA] neg. no. 130177.)

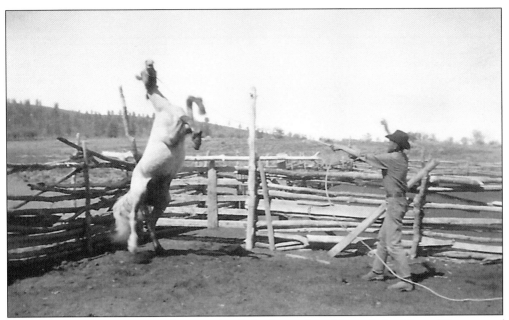

Taylor Monarco is training a horse at his father's ranch at Horse Lake Mesa. (Courtesy of Viola M. Monarco.)

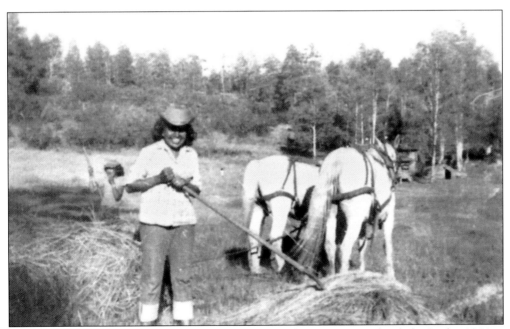

During the fall haying season, all members of the family were expected to help. In this 1944 or 1945 photograph, Eva Martinez is in the background and Dorothy Monarco is in the foreground holds a pitchfork at the Monarco Ranch at Horse Lake Mesa. (Courtesy of Dorothy Velarde.)

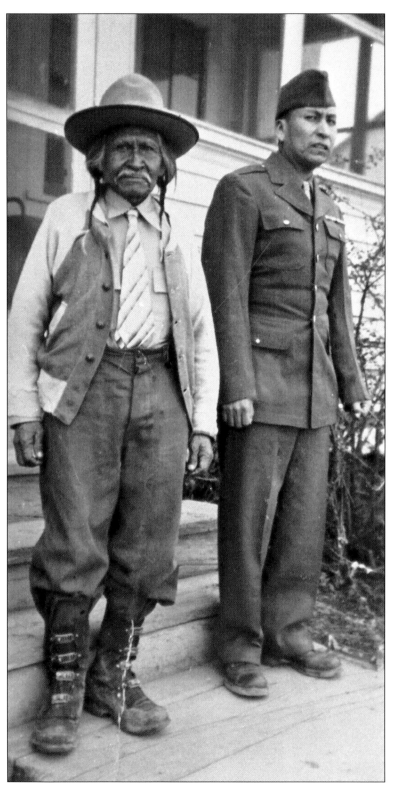

In proportion to its population, the Jicarilla Apache Tribe was well represented in the armed forces of the United States during World War II. No less than 40 young men volunteered to serve their country. In this photograph, Grande Cachucha is standing next to his son Charles on the steps of the Mission. Charles Cachucha served in the US Army during World War II. (Courtesy of Jicarilla Apache Cultural Center.)

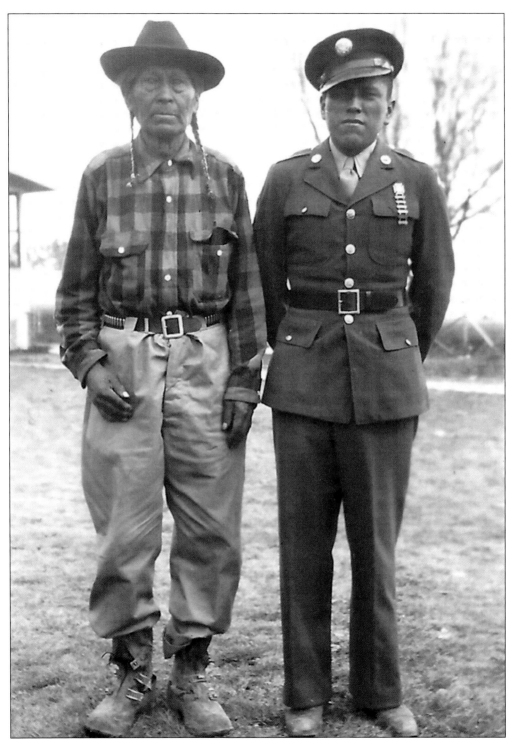

In this photograph, Garfield Velarde Sr. is standing next to his son, Garfield Velarde Jr., who was home on leave from the US Army. Garfield Jr. saw combat action in New Guinea in the Pacific theater of operations during World War II. (Courtesy of Lorene V. Bird Collection.)

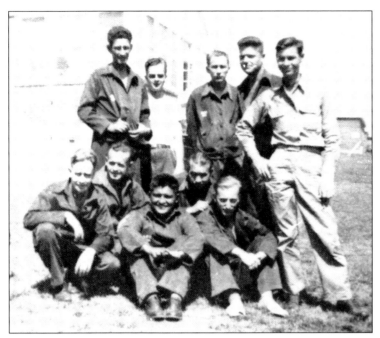

David Velarde Sr. served under Gen. Dwight Eisenhower as an Army Ranger and was wounded during the D-Day Allied Invasion at Normandy Beach on June 6, 1944. In 1952, he petitioned President Eisenhower to allow per capita dividends to tribal members from oil revenues. Velarde is the person sitting on the ground in the front row, between two of his unidentified soldier buddies. (Courtesy of David Velarde Jr.)

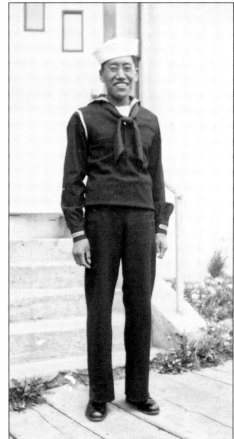

Most young Jicarilla men served in the US Army during World War II. One young man who chose the US Navy was Calvin Vigil. This photograph was taken at the Mission in the 1940s while he was on leave. (Courtesy of the Denver Museum of Nature and Science.)

Laell Vicenti was honored by the Jicarilla Council in 1984 as one of the founders of the National Congress of American Indians in 1944. Pictured from left to right are (first row) Frieda Havens, Laell Vicenti, wife Emma Vicenti, Nina Zentz, and Carl Vicenti; (second row) Vicki Petago, Edward Velarde, Wainwright Velarde, Edwin Sandoval, council president Leonard Atole, and Harrison Elote. (Courtesy of *Jicarilla Chieftain.*)

Frank Vigil was the chairman of the Jicarilla Apache Tribe from 1952 to 1954. During his term, the $1-million Chester E. Faris Scholarship Fund and the Minor's Trust Fund were created for the benefit of tribal youth. The first fund was to provide college and technical training for students, and the other was to assist young adults in starting their households. The funds came from oil and gas revenues. (Courtesy of *Jicarilla Chieftain*.)

Oil and gas reserves were discovered on the southern portion of the reservation in 1952. This 1950s photograph has Clement Monarco standing in front of an oil pumping rig on the southern part of the reservation. (Courtesy of Dorothy Velarde.)

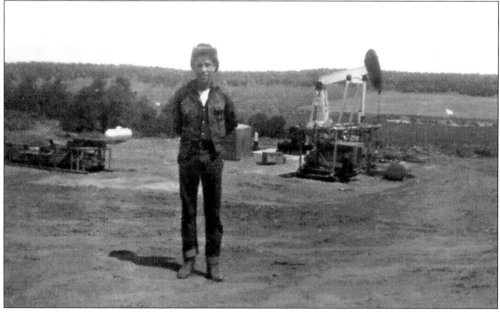

Taylor Monarco served in the US Army during the Korean War. He was on active duty from 1952 to 1953. The photograph below shows him at Camp Pickett, Virginia, while training with Company A Medical Training Battalion. The image at right has him in his combat uniform when he was with the 224th Infantry Battalion, 40th Division at Heart Break Ridge and the Punch Bowl in Korea, where he saw combat action. For his service, Monarco received the Korean Service Medal with three bronze stars, the United Nations Service Medal, and the National Defense Service Medal. (Both, courtesy of Dorothy Velarde.)

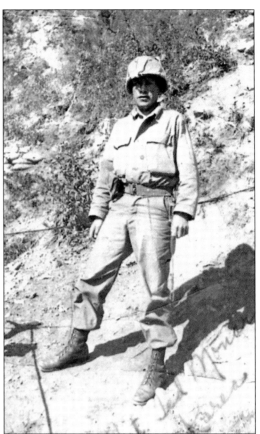

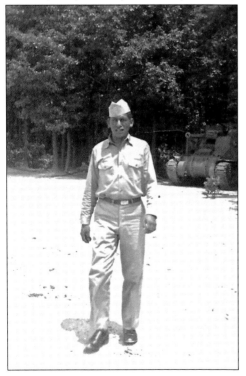

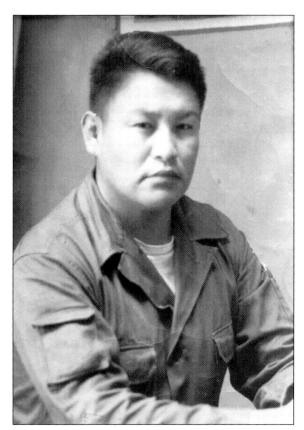

Young Jicarilla men volunteered to serve in the Korean War. Harper Vicenti served in the US Army from May 1945 to November 1946 and returned to active duty for the Korean War. While in the Army, he received training in radio communications and was a marksman with a rifle. He was awarded the Army Occupation Ribbon while in Germany, a Victory Ribbon, and one Overseas Service Bar. The photograph at left shows Harper in his casual uniform. In the bottom photograph, he in the trenches (on the right) in South Korea. (Both, courtesy of Ingeborg Vicenti.)

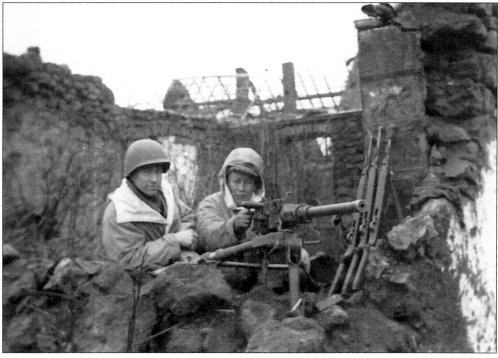

Three

MOVING TO DULCE
1960 TO 1984

With the decline of the livestock industry in the early 1960s, there was a population movement from throughout the huge reservation to Dulce, making it no longer just an agency town but now the headquarters of the Jicarilla Apache tribal government.

Only part of the Wirt Trading Post remained, and the original agency building was torn down. Replacing the old agency site was a new one-story building that housed the tribal government and administration.

In the 1960s, the Jicarilla people who moved into Dulce needed housing, community infrastructures, and jobs. Responding to changing times, the tribe's economic development plan created tribal and governmental jobs tied to its natural resources and a partnership with the federal government through its Great Society programs. To create jobs and provide training opportunities, the timber industry was revived, the first phase of tourism and recreation was initiated, an electronics plant was built, and an arts and crafts industry was started.

With the oil and gas revenues, the tribe pursued the settlement of its land and accounting claims against the federal government by hiring the Nordhaus Law Firm of Albuquerque. With the guidance of this law firm, the tribe began an investment program that increased its financial wealth. By 1979, Dulce had a new tribal headquarters consisting of a community center, a detention center, a new high school, a store, a motel and lounge, a branch bank, a new post office, a gas station, and residential housing units.

The vitality of this bustling new era was reflected in many ways. The tribe saw the increase in its high school graduation rates, college enrollment, and its first college students with undergraduate and graduate degrees. The sport of rodeo took on a new dimension with the establishment of the Little Beaver Round-Up, an annual rodeo and powwow event. A Jicarilla woman became the first vice president of the tribe. On the cultural front, like the livestock industry, interest declined in the 1960s only to rebound in the 1970s.

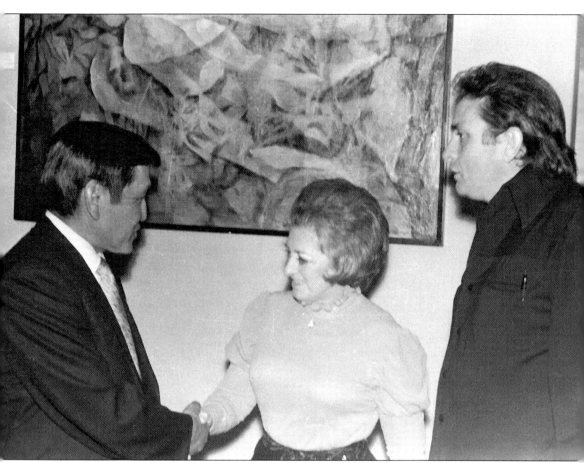

Charlie Vigil was chairman of the tribe from 1964 to 1972. During his presidency, the film industry was introduced to the tribe as an investment. In this photograph, President Vigil is greeting June Carter Cash and singer Johnny Cash. The tribe invested $1 million in the movie *The Gunfight* starring Johnny Cash and Kirk Douglas and received national media coverage for it. (Courtesy of *Jicarilla Chieftain*.)

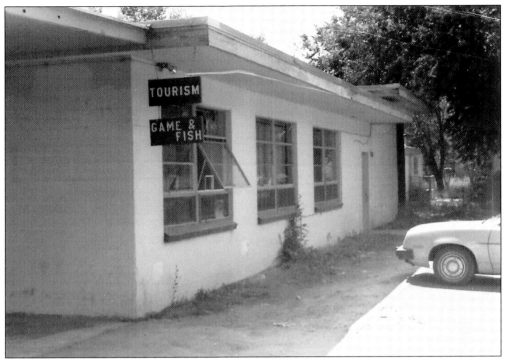

The building in this photograph was originally the new tribal building that was constructed in 1960 when the old agency building and the Jicarilla Cooperative Store were torn down. In the early 1970s, the tribal offices were moved to their current site and this building became the offices of the Jicarilla Game and Fish Department. (Courtesy of Dulce High School Library.)

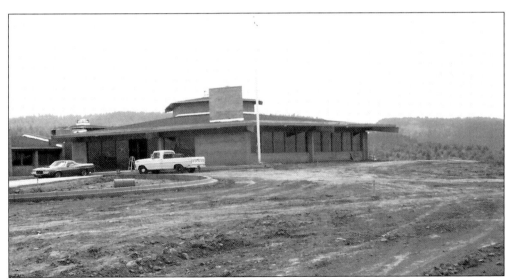

To promote tourism and recreation, the tribe, with funding from the US Economic Development Administration (EDA), built Stone Lake Lodge in the late 1960s. This photograph shows the lodge at Stone Lake just before it was ready to open its doors for business. (Courtesy of *Jicarilla Chieftain*.)

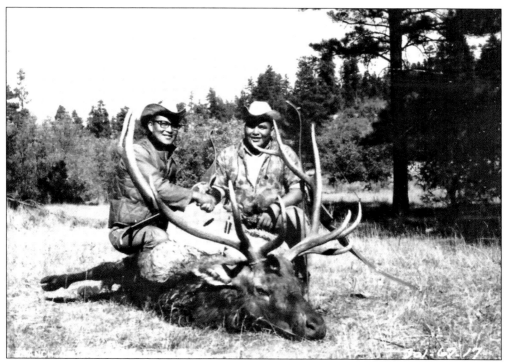

Tourism and recreation became a new tribal enterprise during the 1960s. Big game hunting became a national attraction. In this photograph, two Jicarilla men, Matthew Vigil and Leonard Puerto, have shot an elk. (Courtesy of BIA, Jicarilla Agency.)

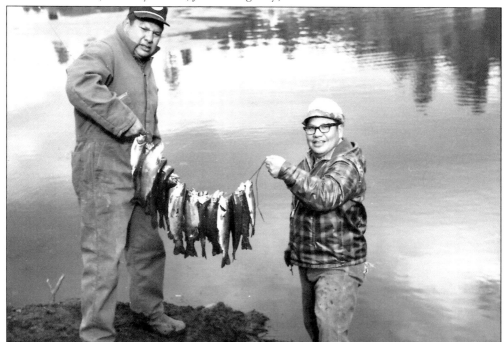

Fishing on the numerous lakes on the reservation promoted tourism, but it also became a family outing for this father and son. (Courtesy of BIA, Jicarilla Agency.)

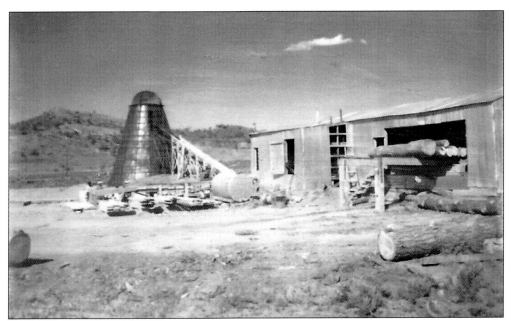

When the timber industry was revived in the 1960s, the tribe purchased a sawmill in 1964. The Jicarilla Lumber Company Sawmill was located in Dulce. (Courtesy of BIA, Jicarilla Agency.)

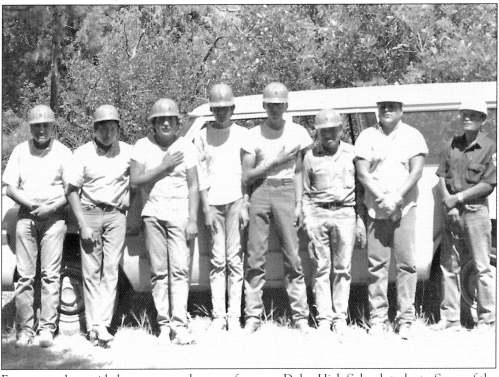

Forestry work provided summer employment for many Dulce High School students. Some of the students, seen here from left to right, are Nelvin Serafin, Arnold Cassador, Marvin Monarco, Gary L. Vicenti, Travis Chavez, Philbert Vigil, Earl Monarco, and supervisor Henry Callado. (Courtesy of BIA, Jicarilla Agency.)

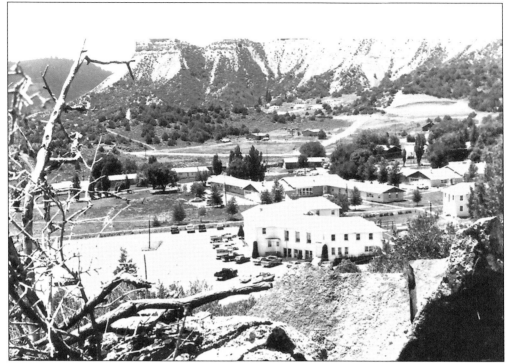

This is an aerial view of the Jicarilla Boarding School campus. Three new L-shaped dormitories—Hiawatha, Wirt, and Stover Halls—were built in 1958. Only Stover Hall, the young girls' dormitory across from Damstra and Faris Halls, is visible in this 1963 photograph. (Courtesy of Jicarilla Cultural Center.)

This BIA boys' dormitory was called Faris Hall. It was still used as a dormitory in the late 1960s. Later, it was converted into government offices when the dormitory closed down in the early 1970s. (Courtesy of Dulce High School Library.)

The Big D Supermarket was built in Dulce in the early 1980s. (Courtesy of Dulce High School Library.)

In this late 1960s photograph, only the Apache Haven Restaurant and Lounge can be seen. Next to it in the complex was a motel. (Courtesy of Dulce High School Library.)

Facing east and south of the tribal administration building are, from left to right, the Dulce Branch of the First National Bank of Rio Arriba, the *Jicarilla Chieftain* office, and the post office. (Courtesy of *Jicarilla Chieftain*.)

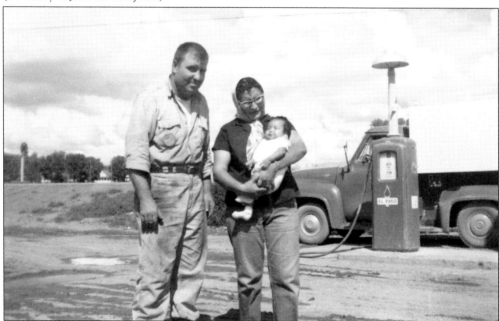

This 1963 photograph shows Kenneth and Lorene Bird with their infant daughter, Loyola, posing at Bird's Garage next to the gas pump. Established in Dulce in 1962, this business was the only successful private enterprise on the reservation. Later, Bird's Garage was relocated along Highway 17 and a wrecker service and car wash were added. Bird's Garage was in business for 31 years. (Courtesy of Lorene Bird Collection.)

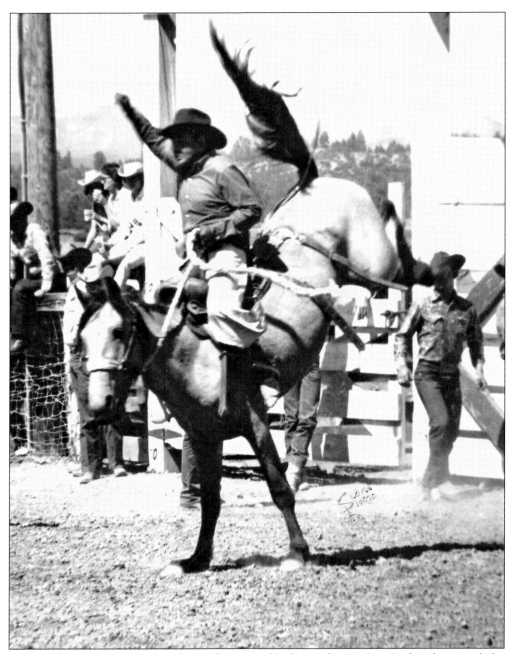

Jackson Velarde has been referred to as the original Indian rodeo cowboy. In this photograph, he is in the saddlebronc-riding event at Chama Day in 1962. Jackson's rodeo career began in 1949 and ended in 1982. One highlight for Jackson was riding at the Cheyenne Frontier Days. An image of his ride at Cheyenne was used to promote this famous RCA rodeo event. (Courtesy of Alberta Velarde.)

In this 1984 photograph, from left to right are Troy Vicenti (the original and first Little Beaver in 1961), Little Beaver Russell Veneno, and Troy's son Jason, who also served as a Little Beaver from 1980 to 1984. (Courtesy of *Jicarilla Chieftain*.)

The Little Beaver Roundup Rodeo (LBR) began in 1961. The first annual LBR rodeo queen was Alberta Velarde. In this photograph from left to right are Mary M. Velarde and Alberta Velarde. They are holding their quarterhorses, Baldy, on the left, and Joe, on the right, at the Dulce Rodeo grounds. (Courtesy of Alberta Velarde.)

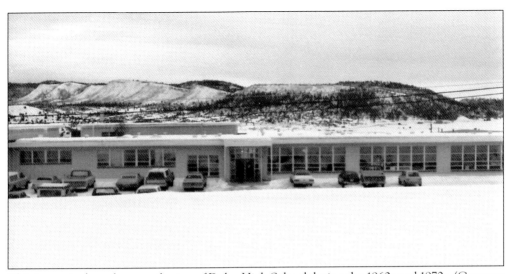

This is a typical north-to-south view of Dulce High School during the 1960s and 1970s. (Courtesy of Dulce High School Library.)

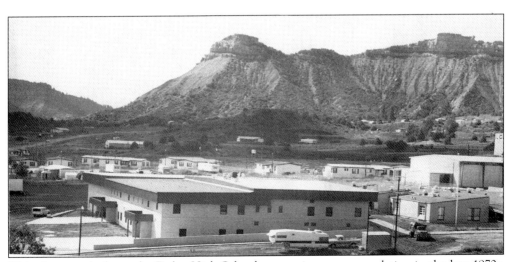

This photograph shows the Dulce High School gymnasium near completion in the late 1970s. (Courtesy of *Jicarilla Chieftain*.)

Army private Everett Serafin is at Fort Belvoir, Virginia, to escort Lynda Bird Johnson on her June 1967 visit. Everett served in Vietnam in 35th Field Artillery Unit from 1968 to 1969. His awards included the National Defense Service Medal, Vietnam Service Medal with two stars, Vietnam Campaign Medal, Rifle Expert, Pistol Sharpshooter, and a Good Conduct Medal and Mechanic Badge. (Courtesy of Roberta Serafin.)

In this photograph, taken on April 11, 1969, Army specialist fourth class Everett Serafin is with his wife, Roberta Serafin, at the Albuquerque Sunport (now the Albuquerque International Airport). Everett had returned from his tour of duty in Vietnam, and after a 30-day leave, he was on his way to Fort Benning, Georgia, to complete his Army tour of duty. (Courtesy of Roberta Serafin.)

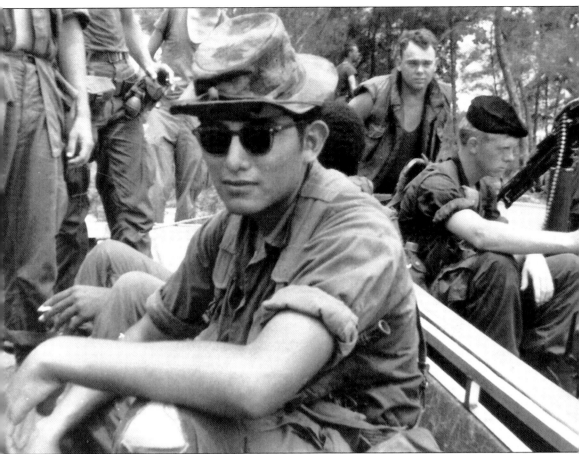

Leroy TeCube is north of Chu Lai, South Vietnam, with the Army's 23rd Infantry Division. TeCube served in Vietnam from 1968 to 1969 and participated in search-and-destroy missions with the Americal Division. In 1999, he chronicled his experiences in his book *Year in Nam*, published by the University of Nebraska Press. He won an American Book Award for this memoir. (Courtesy of Leroy TeCube.)

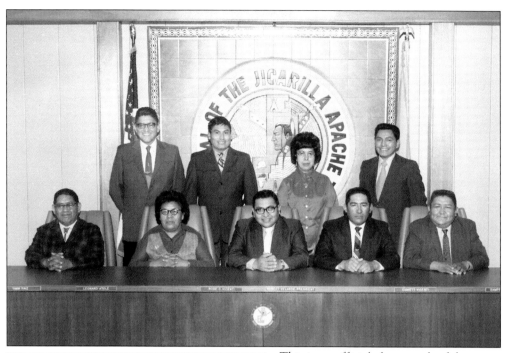

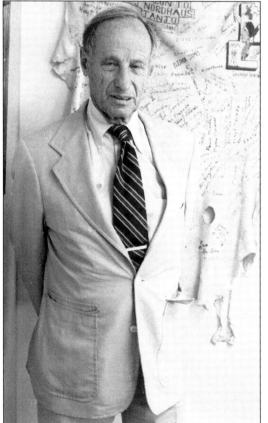

This is an official photograph of the 1972–1976 Jicarilla Apache Tribal Council members. They are, from left to right, (first row) Leonard Atole, Vice Pres. Rose Callado, Pres. Hubert Velarde, Emmet Vicenti, and Sampson Baltazar; (second row) Edwin Sandoval, Tim Paiz, Barbara Gonzales, and Everett Vigil. In 1972, Hubert Velarde was elected as president of the Jicarilla Apache Tribe. He served until 1977. Rose Callado was the first Jicarilla woman to serve as tribal vice president. (Courtesy of *Jicarilla Chieftain*.)

The Jicarilla Apache Land Claim was filed in 1948 under the Indian Claims Act of 1946 for lands wrongfully taken from the Jicarilla in 1883. Attorney Robert Nordhaus of Albuquerque announced the award of monies in 1971 at a community assembly. He is standing next to a buckskin signed by members of the tribe thanking him for his service. (Courtesy of *Jicarilla Chieftain*.)

In 1976, the tribe established the Jicarilla Apache Energy Company (JAECO). In this 1984 photograph, JAECO is exhibiting at a conference. Standing from left to right are Robert Martinez, Pres. Leonard Atole, and Ahmed Kooros of the Council of Energy Resource Tribes of Denver. (Courtesy of *Jicarilla Chieftain*.)

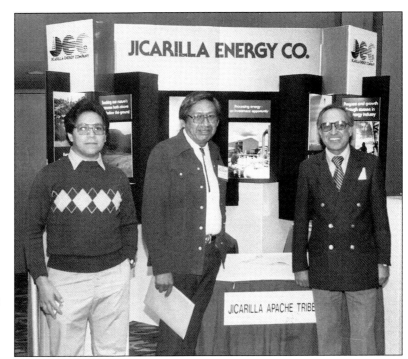

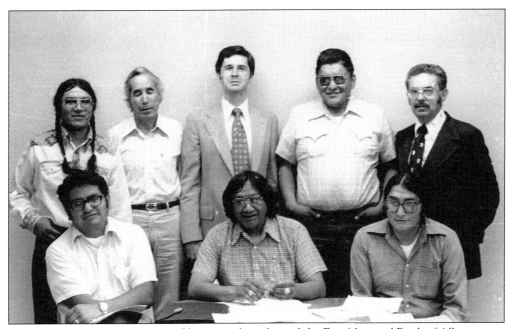

A real estate agreement was signed between the tribe and the First National Bank of Albuquerque on August 11, 1978. Present for the signing were, from left to right, (first row) Thurman Velarde, Pres. Leonard Atole, and Richard TeCube; (second row) Arnold Cassador, Gabriel Abeyta, Bill Wissert, Edwin Sandoval, and John Roberts. (Courtesy of *Jicarilla Chieftain*.)

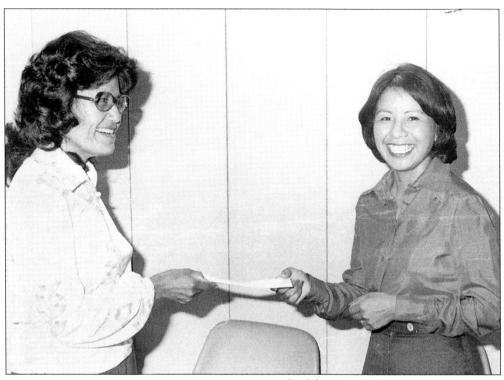

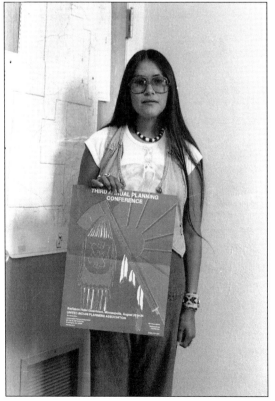

On July 19, 1977, Frieda Havens, chairperson of the Chester E. Faris Scholarship Fund, presented Veronica E. Velarde Tiller with a $1,000 award for being the first Jicarilla Apache tribal member to receive a doctor of philosophy degree. Tiller received her PhD from the University of New Mexico in 1976. She was teaching at the University of Utah at the time of the award. (Courtesy of *Jicarilla Chieftain*.)

While a student at the Institute of American Indian Arts of Santa Fe, Vida Vigil won the national poster contest for the United Indian Planners Association. The announcement was made in August 1978 in Minneapolis. (Courtesy of *Jicarilla Chieftain*.)

A second bridge across Amargo Creek was built in 1977. (Courtesy *Jicarilla Chieftain*.)

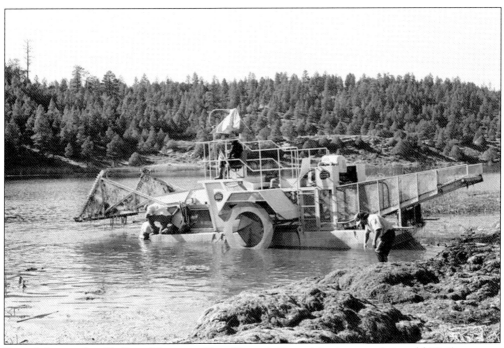

From left to right, Philbert Monarco, Troy Vicenti, Steve Martinez, and Arnold Vigil are seen in this photograph completing the fall weed cutting at Dulce Lake in October 1979. This is part of the work carried out by the Jicarilla Game and Fish Department to improve the fishing on all the reservation lakes. (Courtesy of *Jicarilla Chieftain*.)

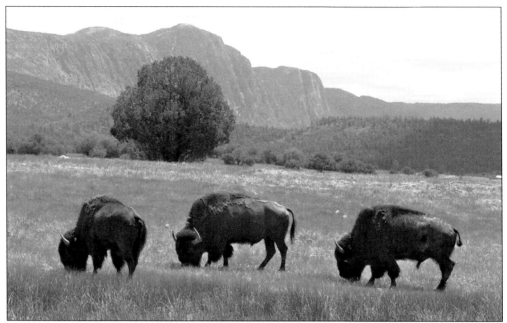

There is a herd of over 75 bison at the ranch at the Lodge at Chama. The tribe purchased the 32,075-acre Chama Land and Cattle Company in June 1995. (Courtesy of Jicarilla Game and Fish Department.)

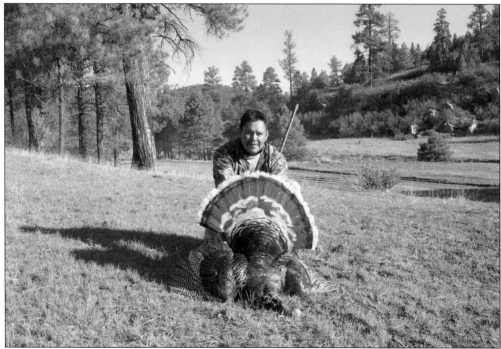

The Jicarilla Reservation has a diversity of species of wildlife game, including the mule deer, Rocky Mountain elk, black bear, mountain lion, Merriam's wild turkey, and a variety of small game. In this photograph, tribal member Larry Panzy has killed a wild turkey. (Courtesy of Jicarilla Game and Fish Department.)

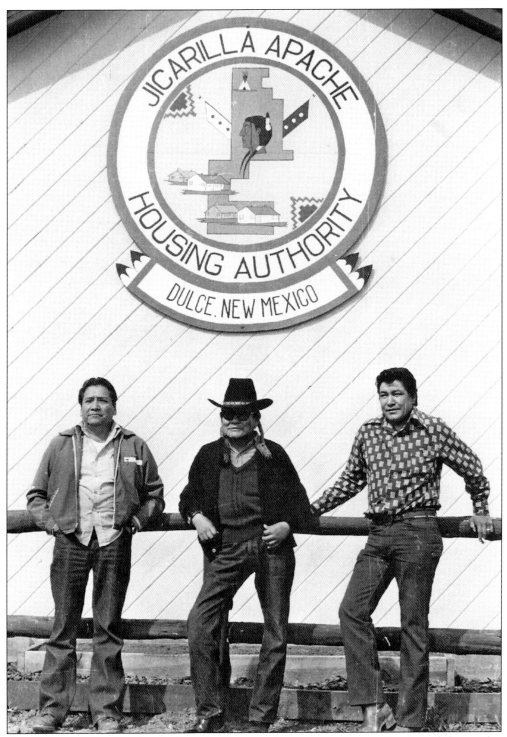

Designing the new sign for the Jicarilla Housing Authority were, standing from left to right, Nossman Vigil, Harper Vicenti, and Willie Garcia, the housing director. Both Vigil and Vicenti are renowned tribal artists. (Courtesy of *Jicarilla Chieftain*.)

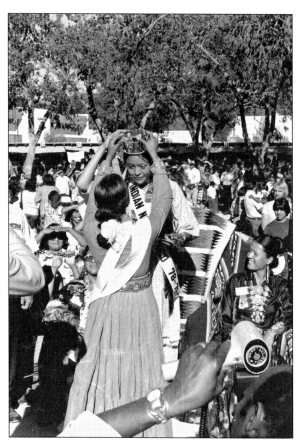

In this photograph, Miss Indian New Mexico Leva DeDios receives the official crown from the outgoing Miss Indian New Mexico during Indian Day at the New Mexico State Fair in September 1978. DeDios was the first Jicarilla Apache tribal member to receive this honor. At the time, she was a student at the Institute of Indian Arts in Santa Fe. (Courtesy of *Jicarilla Chieftain*.)

The women in this photograph show off their winning entries of fine Jicarilla basketry and arts at the New Mexico State Fair in 1980. They are, from left to right, Floripa Manwell, Columbia Vigil, Grace Maria, Bertha Velarde, Ardella Veneno, and Cecelia Harina. (Courtesy of *Jicarilla Chieftain*.)

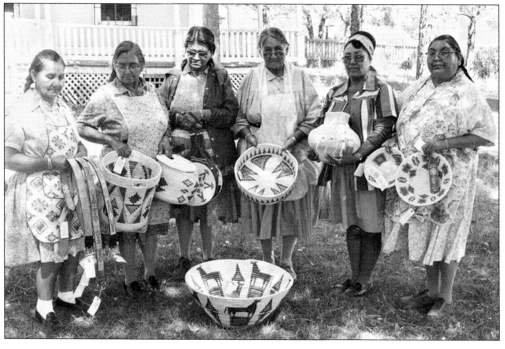

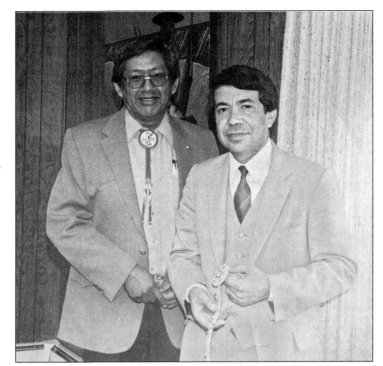

Leonard Atole served four four-year terms as president of the Jicarilla Apache Tribe, starting in 1980. He was reelected in 1984 and then again in 1992 and 1996. Standing to the right of Atole is Gov. Tony Anaya of New Mexico. (Courtesy of *Jicarilla Chieftain*.)

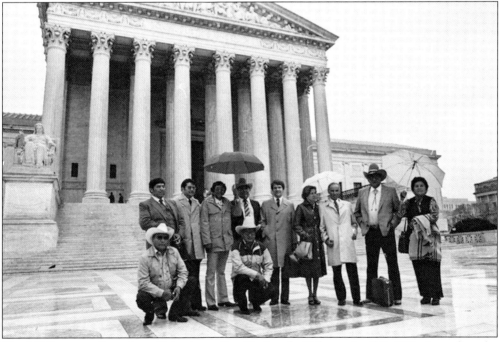

The US Supreme Court heard *Merrion v. Jicarilla Apache Tribe* on April 2, 1981. Attending the historic hearing were, from left to right, (first row) Calvin Veneno and Wainwright Velarde; (second row) Rudolfo Velarde, Thurman Velarde, Pres. Leonard Atole, Harrison Elote, Terry Farmer, Marge Nordhaus, Robert Nordhaus, Edwin Sandoval, and Cora Gomez. (Courtesy of *Jicarilla Chieftain*.)

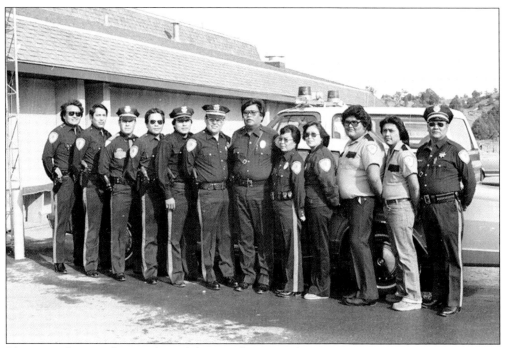

This 1981 photograph was taken of the Jicarilla Law Enforcement personnel. From left to right, they are Hoyt Velarde, Jonathan Washington, Gabe Valdez, Eddie Wanoskia, Jim Atole, Juan White, Tom Trujillo, Gloria Reval, Sharon Julian, Chucky Paiz, Eddie Willie, and Wilfred Reval. (Courtesy of *Jicarilla Chieftain*.)

Over the years, it was not uncommon to see Wainwright Velarde participate and support Jicarilla public events and represent the tribe at national meetings. He has spent many hours testifying before congressional and state committees on issues of critical importance to the tribe, from housing to water rights, during his tenure as councilman. (Courtesy of *Jicarilla Chieftain*.)

Dulce Volunteer Fire Department officers elected new officers in April 1981. From left to right are Emilio Cordova, secretary-treasurer; Tony Pena, fire chief; Leroy TeCube, fire marshal; and Bill Vicenti, first assistant fire chief. (Courtesy of *Jicarilla Chieftain*.)

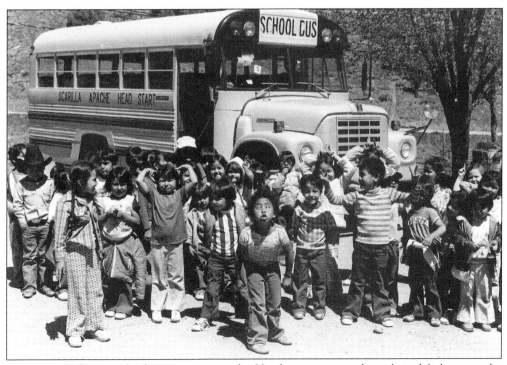

In this 1978 photograph, the youngsters at the Headstart program show their delight upon the arrival of a well-equipped school bus. (Courtesy of *Jicarilla Chieftain*.)

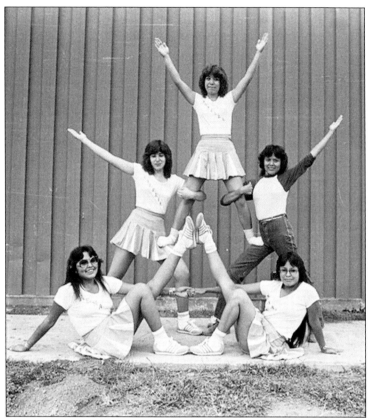

Dulce High School cheerleaders for 1981 were Norvella Cordova (the top of the group pyramid), Valerie Gomez and Crystal Veneno (from left to right on the second tier), and Dorene Velarde and Renae Eaton (from left to right, seated on the ground). Their sponsor was Yvette Montoya. (Courtesy of *Jicarilla Chieftain*.)

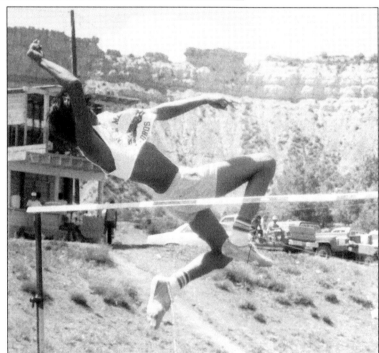

A Dulce High School student athlete clears the bar against the canyon walls of Dulce Rock. (Courtesy of *Jicarilla Chieftain*.)

Lavelle Tafoya is holding her album *Waiting for Dreams*, released in December 1981. She was one of the first Jicarilla singers and composers to record an album. She classified her songs as country music. (Courtesy *Jicarilla Chieftain*.)

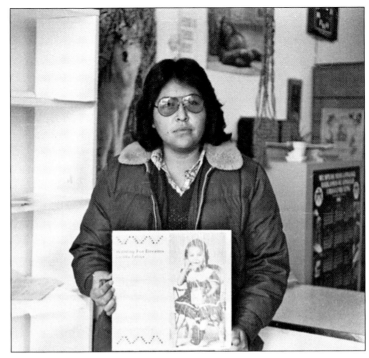

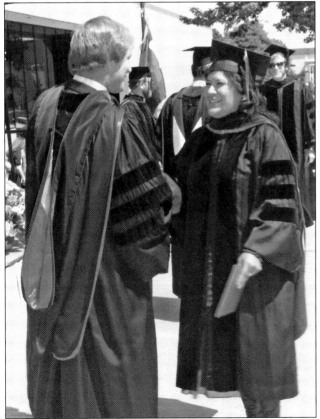

On June 9, 1984, Bernice G. Muskrat received her law degree from the University of Denver Law School, making her the first Jicarilla Apache to receive a law degree. Conferring the diploma is the dean of the law school. (Courtesy of Roberta Serafin.)

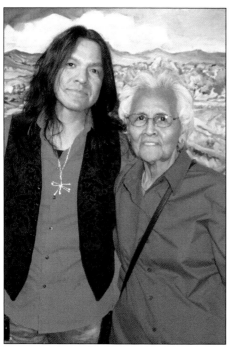

Darren Vigil Gray is a modern abstract expressionist painter who started his professional career in the 1980s. Since then, he has become world-renowned, and his paintings are on display at the Smithsonian, Heard Museum, Denver Art Museum, the Museum of Mankind in Vienna, and many others. In this photograph, he poses with his mother, Thaymeus B. Vigil, at the LewAllen Gallery in Santa Fe. (Courtesy of Darren Vigil Gray.)

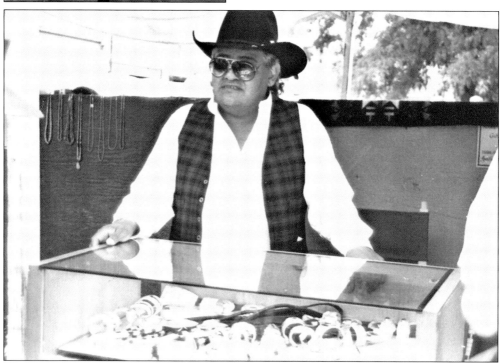

Gibson Nez started his successful silver jewelry business in the 1970s. Gibson's unique and one-of-a-kind jewelry was shown at national art shows and galleries throughout the United States. One of his favorite shows was the Santa Fe Indian Market, where he showed every year. Among his celebrity clients were Liz Taylor, Lorne Greene, Larry Hackman, and Goldie Hawn. (Courtesy of *Jicarilla Chieftain*.)

Lydia Pesata, a basket maker and potter, is seen in this photograph showing her artistic work. Lydia is perhaps the most influential Jicarilla Apache basket weaver of modern times. She is credited with the revival of Jicarilla micaceous pottery. She has won many awards, including the New Mexico Governor's Award for Excellence in the Arts in 1988 and the Southwest Association for Indian Arts Lifetime Achievement Award. (Courtesy of *Jicarilla Chieftain*.)

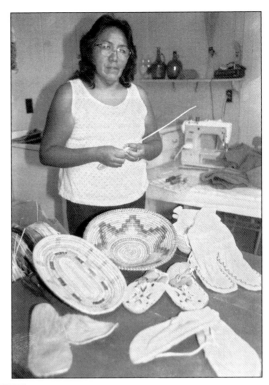

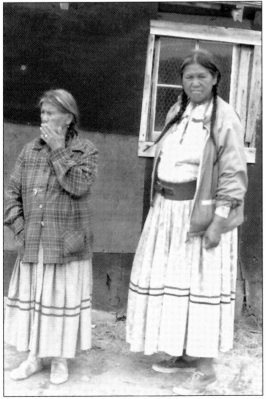

The elders are always around to remind the young of their Apache ways. Without them, the Jicarilla Apache tribe would not be the tribe it is today. Juana Monarco (left) and Lily Lovato (right) were two elders who made sure that Apache culture and customs survived into the future. (Courtesy of Viola M. Vicenti.)

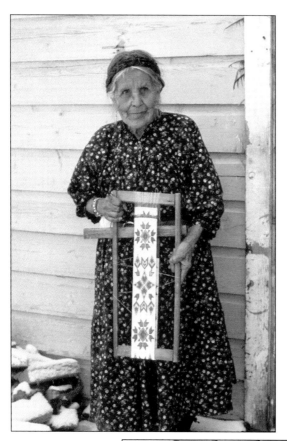

One of the most venerable Jicarilla elders was Petklo Garcia. She was responsible for staging *keestas* for all young females in her extended family during the 1960s and 1970s and keeping Jicarilla culture alive. In the 1960s, she was a tribal judge. Here, she stands next to her house at La Jara holding her beadwork, which is still on a loom. (Courtesy of the Denver Museum of Nature and Science.)

These five Jicarilla girls, dressed in their traditional and colorful Goijiya outfits, are ready to go to the races. All their dresses were made by their grandmother, Rebecca Martinez. From left to right are Emily Tiller, Reba June Serafin, Dawn Muskrat, Bobbienell Velarde, and Stacey Velarde. (Courtesy of Alberta Velarde.)

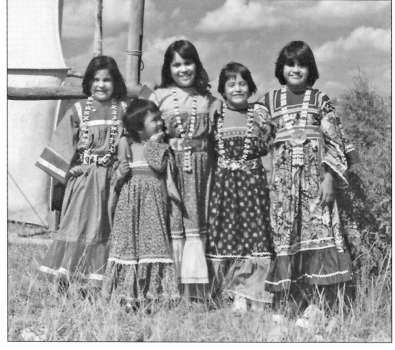

Reba June Serafin poses at the 1992 Quarter Horse Show at the New Mexico State Fair with her first-place ribbons. From 1986 to 1992, she was a top competitor in the New Mexico Junior Quarter Horse Association, winning the prestigious Warren Shoemaker Memorial Award and the Wes Brewer Sportmanship Award. From left to right are Lindbergh Velarde, Roberta Serafin, and Maxine Velarde. (Courtesy of New Mexico State Fair.)

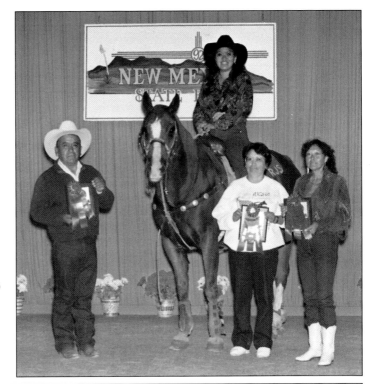

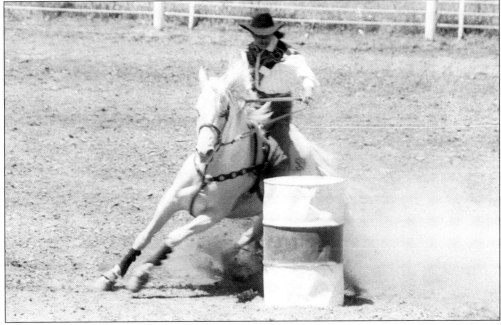

Stacey Velarde is barrel racing at the 1991 Little Beaver Roundup, where she not only won the barrel racing but was also the rodeo queen. Velarde was a top barrel racer in the Little Britches Rodeo circuit of Colorado and the first Native American to be a member of the Women's Professional Rodeo Association from 1984 to 1989. In 1984, she was Colorado Circuit Rookie of the Year. (Courtesy of *Jicarilla Chieftain*.)

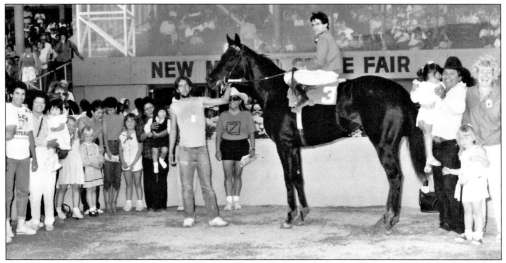

In the winner's circle at the New Mexico State Fair is trainer Bob Velarde, who is standing behind his Thoroughbred racehorse and holding his daughter, Blair. Next to him is his wife, Bette. Velarde was a licensed by the six state racing commissions from 1988 to 1995. His horses made the winner's circle at Albuquerque Downs, Santa Fe Downs, San Juan Downs, Sunland Park, and Prairie Meadows in Iowa. (Courtesy of New Mexico State Fair.)

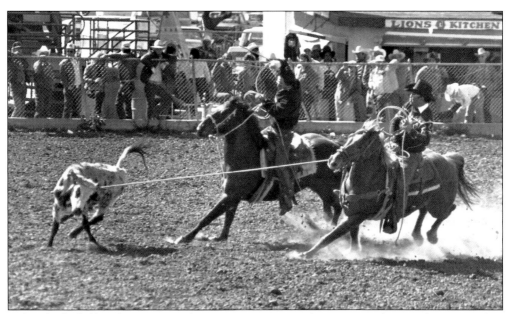

Bob Velarde (left) and Everett Serafin are team roping on their registered quarterhorses Sawdust (on the left) and Vino (on the right) in Casa Grande, Arizona, in 1982. Like many Jicarilla cowboys, both Bob and Everett have been life-long team ropers competing in amateur rodeo events throughout the Southwest. (Courtesy of Roberta Serafin.)

Four

MODERN TIMES
1985 TO 2000

The last 15 years of the 20th century found the Jicarilla Apache Tribe enjoying the success of its past efforts. The tribe had become a national leader in reservation energy development and making Indian energy law. This action went hand in hand with taking on several oil companies operating on the reservation, all the way to the US Supreme Court. In the 1981 case of *Merrion v. the Jicarilla Apache Tribe*, the high court ruled that the tribe had the right to impose a severance tax on minerals extracted from Indian lands. Following this decision were also numerous suits against major oil companies for underpayment of royalties. A similar scenario occurred with the settlement of the tribe's water rights in the 1992 Jicarilla Apache Water Settlement Act.

With revenue from these suits, the tribe was able to purchase over 100,000 acres of land surrounding its reservation. The first purchase was solely funded by a bond issue, another first in Indian country. The tribe diversified its real estate holdings by purchasing off-reservation properties in Florida, Wyoming, and Arkansas. The community of Dulce benefitted from tribal revenues with the building of a community center, a law enforcement facility, and a variety of retail establishments, schools, recreational facilities, and many other amenities found in small rural New Mexico towns. Its economy, based on agriculture, mining, forestry, retail, recreation, and tourism industries, provided income to the tribe. During these decades, the tribe was intent on managing all its natural resources in the best possible manner to secure a productive land base for future generations while preserving the delicate ecosystem of tribal lands. This approach included the protection, improvement, and restoration of wildlife and fisheries habitats and the employment of advanced and comprehensive forest management practices.

Starting with its 100th anniversary of the establishment of its 1887 reservation, the tribe began the recognition and acknowledgement of the successes and achievement of its individual members. The Jicarilla Apache entered the 21st century knowing they had come a long way since 1887.

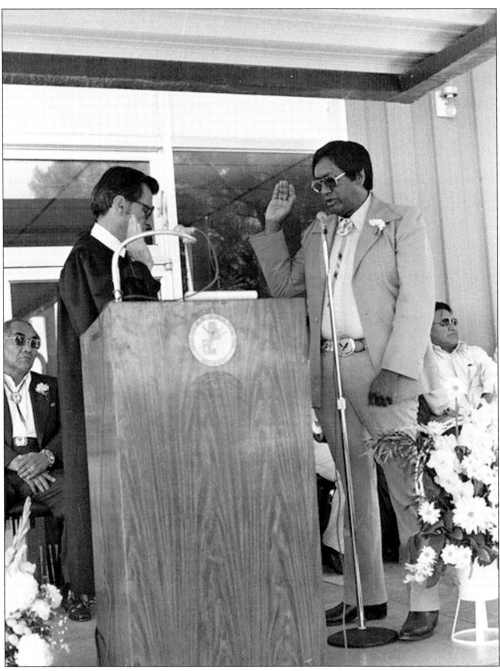

Leonard Atole is being sworn in for his fourth term as president of the Jicarilla Apache Tribe. Seated to the left of the judge is Pres. Wendell Chino of the Mescalero Apache, and seated to the right of President Atole is Calvin Veneno. (Courtesy of *Jicarilla Chieftain*.)

Councilman Ronald Julian witnesses Freda L. Wabnum taking oath of office as associate tribal judge as administered by Pres. Leonard Atole in July 1986. (*Courtesy of Jicarilla Chieftain.*)

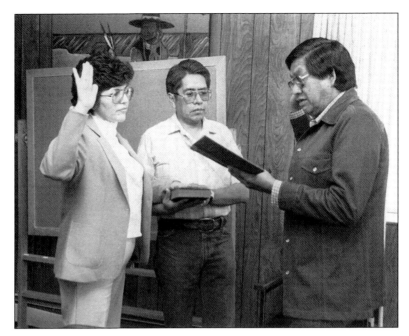

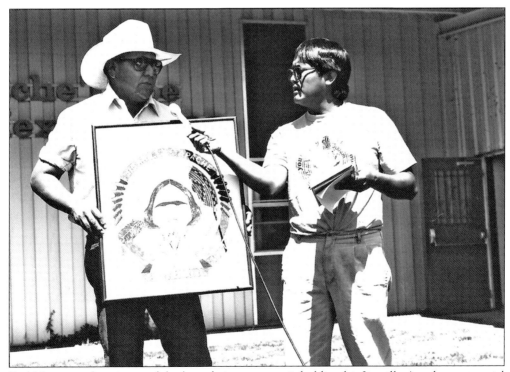

Earl Monarco, the winner of the logo design contest, is holding his Jicarilla Apache centennial logo (1887–1987). Interviewing him is David Velarde Jr. for the Jicarilla Youth Department. (Courtesy of Jicarilla Apache Cultural Center.)

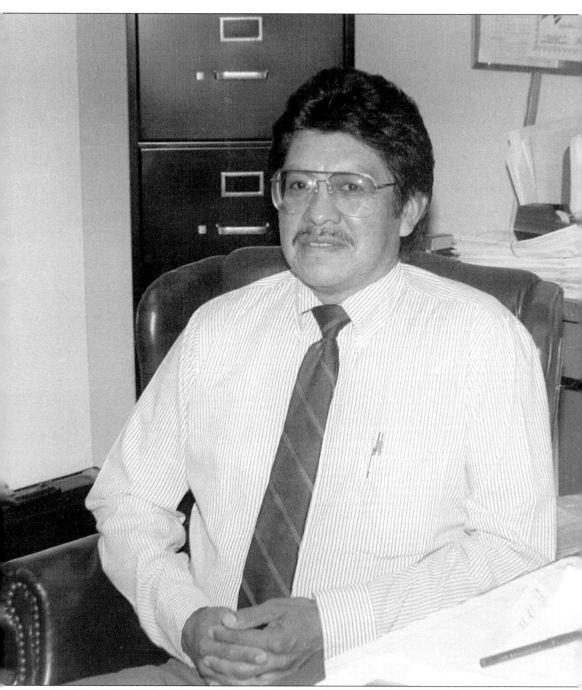

Levi Pesata has had a distinguished public service record for his tribe. He earned his master of arts degree in elementary education from the Arizona State University and went on to serve as the Dulce Elementary School principal and as the director of the Jicarilla Apache Department of Education. From 1989 to 1992, he served his first term as president of the tribe. (Courtesy of *Jicarilla Chieftain*.)

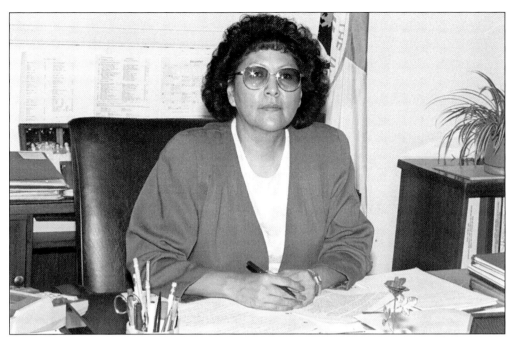

Sherryl Quintana Vigil has served as Jicarilla Agency superintendent since 1986. In that year, she was one of only five women within the Bureau of Indian Affairs throughout the entire nation to be appointed as superintendent of an agency. (Courtesy of *Jicarilla Chieftain*.)

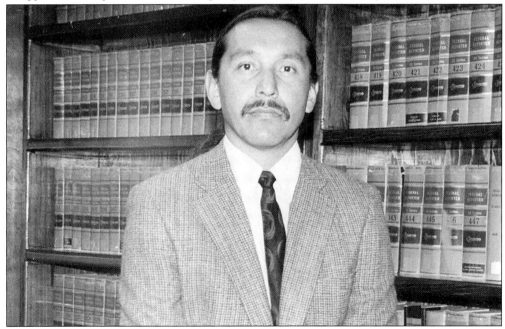

Carey Vicenti served a dual role as a judge for the Jicarilla Apache Court and as an in-house counsel to the nation from 1985 to 1998. During this time, he was instrumental in revising the Jicarilla Apache tribal code and proposed the creation of the Per Capita Trust Fund, which was adopted and became the source of per capita payments to all members of the nation. (Courtesy of *Jicarilla Chieftain*.)

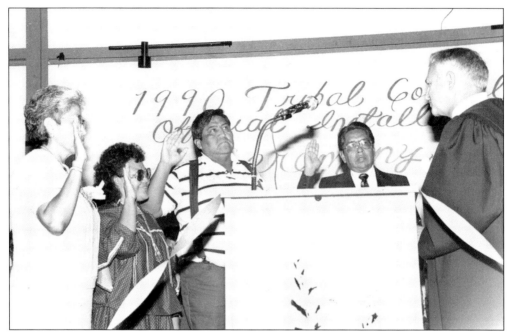

New 1990 tribal council members were sworn in by New Mexico Supreme Court justice Richard R. Ransom at the inaugural ceremonies on August 3, 1990, at the Dulce Community Center. Standing from left to right are Frieda Havens, Loretta Vicenti, Rudy Velarde, and Edward Velarde. (Courtesy of *Jicarilla Chieftain*.)

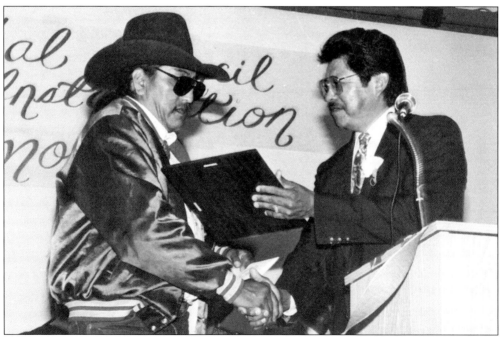

Clyde Vicenti is being thanked by Pres. Levi Pesata for serving on the tribal council from 1986 to 1990. (Courtesy of *Jicarilla Chieftain*.)

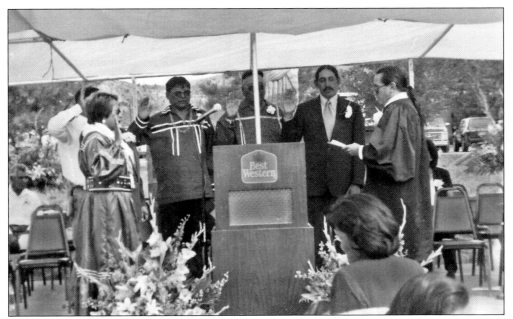

Claudia Vigil-Muniz was elected president of the Jicarilla Apache Nation in September 2000. She was the first woman president of the nation. In this photograph are, from left to right, Pres. Claudia J. Vigil-Muniz and the newly elected councilmen Troy Vicenti, Lester Andrez, Hubert H. Muniz, and Carson N. Vicenti. Judge Melvin Stoof is administering the oaths of office. (Courtesy of Claudia Vigil-Muniz.)

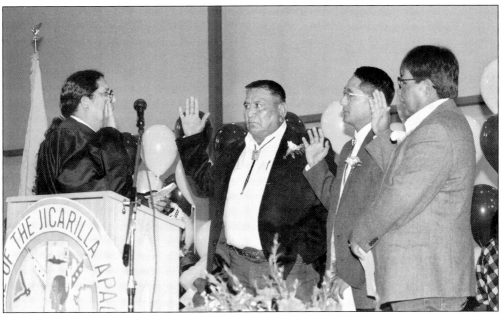

Judge Jim James administers the oath of office to councilmen (from left to right) Harrison Elote, Stanford Salazar, and Ty Vicenti. Elote and Vicenti were reelected, and Salazar was newly elected. (Courtesy of *Jicarilla Chieftain*.)

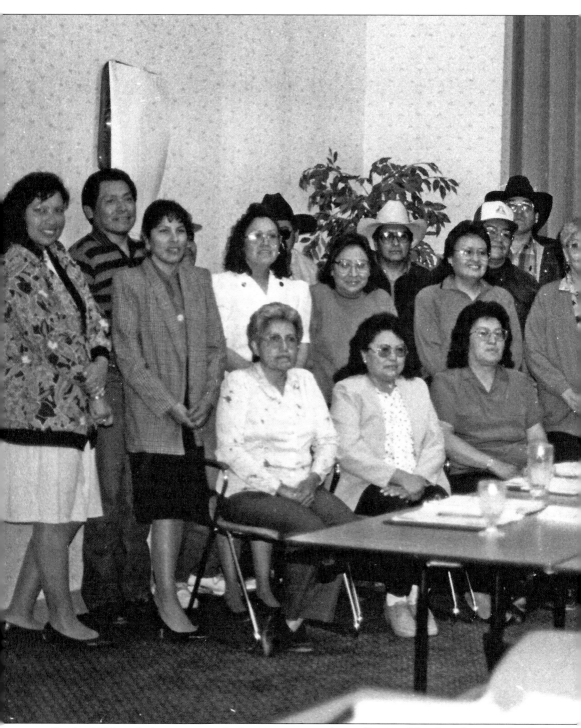

By the 1990s, tribal government had grown immensely, as illustrated by this photograph of all department directors. From left to right are (first row) Frieda Havens, Loretta Vicenti, Prescilla Vigil, Lou Karen Ross, Rudy Velarde, and Terrance Julian; (second row) Janie Zah, Lorene Castleberry, Koy Perea, Sharon Monarco, Marabella Nunez, Pamela Maestas, Myra Sandoval, Ella

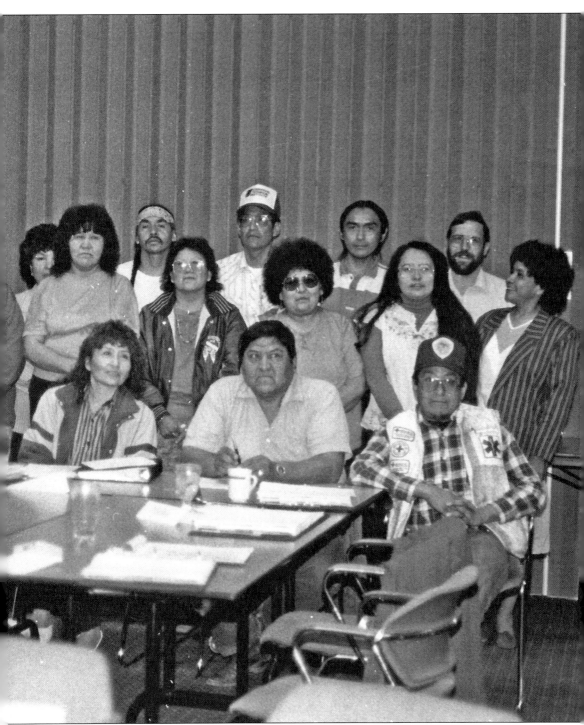

Vicenti, Miriam Quintana, Janell Trujillo, and Alberta Velarde-Vigil; (third row) Everett Vigil, Galvin Phone, Wilbert Montoya, Joe Paquin, Stix Largo, Iola Begay, Merlin Tafoya, Franklin Vigil, Leland DeDios, and Ray Herbal. (Courtesy of *Jicarilla Chieftain*.)

On January 12, 1990, tribal secretary Barbara Gonzales presented Years of Service Awards for Tribal Administration to the tribal secretarial and administrative staff. From left to right are (first row) Juanita Garcia and Elizabeth Velarde; (second row) Barbara Gonzalez, Corine Puerto, Verda DeJesus, Melanie Julian, Adeline Montoya, and Lisa Manwell. (Courtesy of *Jicarilla Chieftain*.)

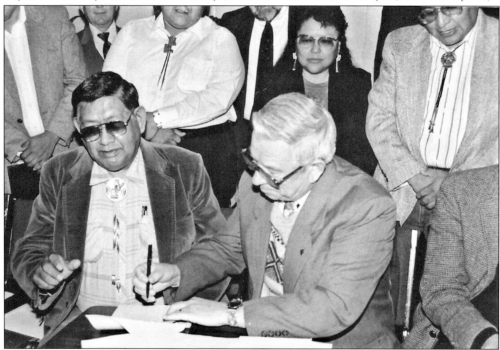

At least 150 people attended a meeting on December 8, 1992, when Pres. Leonard Atole (seated on the left) and Interior Secretary Manuel Lujan (seated on the right) signed the Jicarilla Apache Water Rights Settlement Agreement of 1992. Standing directly behind Secretary Lujan are, from left to right, Councilwoman Loretta Vicenti and Councilman Hubert Velarde. (Courtesy of *Jicarilla Chieftain*.)

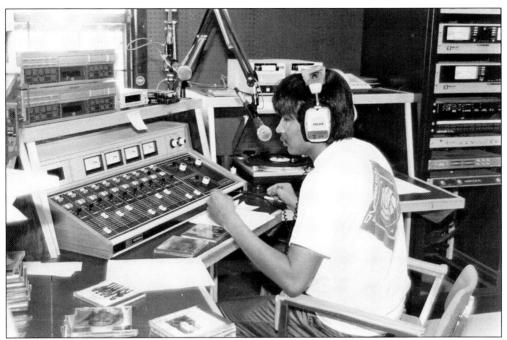

December 3, 1990, was the first day of broadcasting for the local radio station KCIE 90.5. The 100-watt station was licensed to the Jicarilla Apache Communications Department. Biskie Loretto trained as a DJ, and in this photograph, he is announcing. (Courtesy of *Jicarilla Chieftain*.)

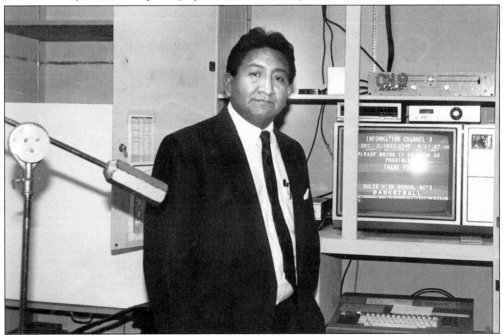

Malcom Electric Warrior studied at the Hollywood Film Institute and was certified as a cinema director and film producer in August 1993. He has been credited with the successful launching of Channel 9, an educational channel for the community of Dulce, in November 1993. Channel 9 was housed in the Jicarilla Apache Department of Education. (Courtesy of *Jicarilla Chieftain*.)

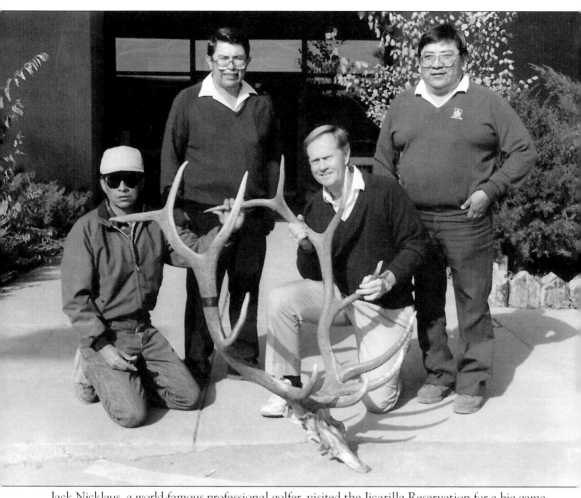

Jack Nicklaus, a world-famous professional golfer, visited the Jicarilla Reservation for a big game hunt. He killed a bull elk on Apache Mesa after three days of hunting. From left to right in this photograph, taken in front of the Jicarilla Inn, are Eugene Chaves, who was a guide to Nicklaus, Tom Vigil, Jack Nicklaus, and Alfred Vigil. (Courtesy of *Jicarilla Chieftain*.)

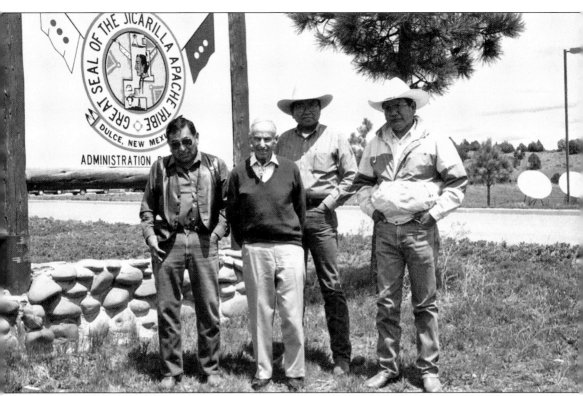

In this 1993 photograph, from left to right, Councilman Hubert Velarde, tribal attorney Robert Nordhaus, Stanley Montoya, and Edward Velarde stand in front of a tribal sign across from the tribal building just before a council meeting. (Courtesy of *Jicarilla Chieftain.*)

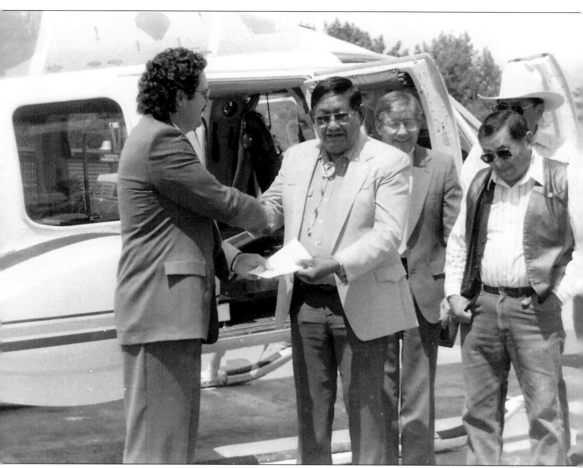

A $15,000 donation was made in May 1993 to the Aeromedical Service of the San Juan Medical Center in Farmington, New Mexico, for its services to the Jicarilla community. In this photograph, Pres. Leonard Atole makes the donation to two representatives from the medical center. Standing from left to right are an unidentified representative, Pres. Leonard Atole, another unidentified representative, and Councilman Hubert Velarde. Standing directly behind Hubert Velarde is Councilman Edward Velarde. (Courtesy of *Jicarilla Chieftain*.)

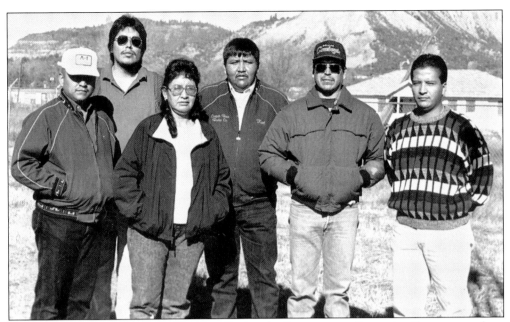

In this photograph of the staff of the Jicarilla Apache Environment Protection Program are, from left to right, Jason Vicenti, Kerwin Tafoya, Irma Serafin, Environmental Protection Agency (EPA) director Kurt Sandoval, Frank Gomez, and Leeson Velarde. (Courtesy of *Jicarilla Chieftain*.)

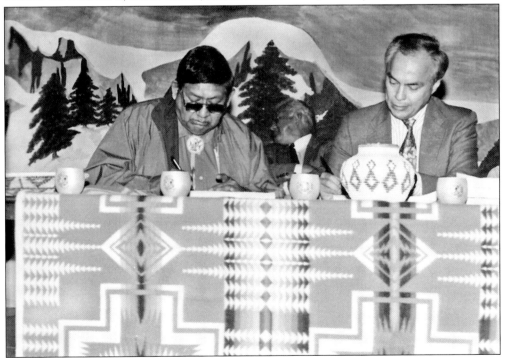

In 1994, the Jicarilla Apache Tribe took over the BIA roads program under the Indian Self-Determination and Educational Assistance Act of January 4, 1975. Signing the document in this photograph are Pres. Leonard Atole and Mike Perry, contracting officer from the Albuquerque Area Office of the Bureau of Indian Affairs. (Courtesy of the *Jicarilla Chieftain*.)

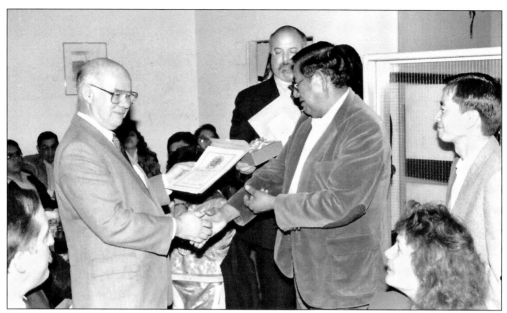

Pres. Leonard Atole gives David C. Harrison a certificate of appreciation for his assistance in a settlement of more than $1 million with Conoco in 1993. Also awarded were attorney Alan Taradash (standing behind President Atole) and tribal tax and revenue director David Wong, looking on from the right. Over a period of 20 years, this team collected scores of millions of dollars in underpaid royalties to the tribe. (Courtesy of BIA, Jicarilla Agency.)

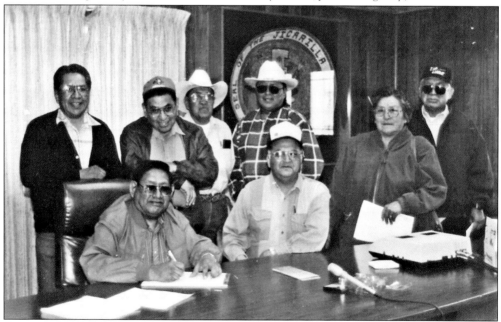

A ceremony was held when the Tribal Elders Trust Fund was created in 1995 to provide monthly assistance to members over 60 years old. Present for the signing were, from left to right, (first row) Pres. Leonard Atole and Health and Social Security director Denton Garcia; (second row) Ronald Julian, Hubert Velarde, Dale Vigil, Ty Vicenti, Senior Citizens director Cora Gomez, and Jonathan Wells. (Courtesy of *Jicarilla Chieftain*.)

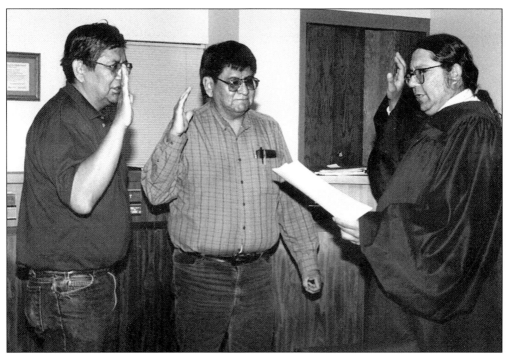

The Sandoval brothers take their oaths of office to serve on the Dulce Public School Board in 1995. Standing on the left is Hobson, who was elected as vice president, and Lester is on the right. Lester was elected as president of the school board. Administering the oath is Judge Jim James. (Courtesy of *Jicarilla Chieftain*.)

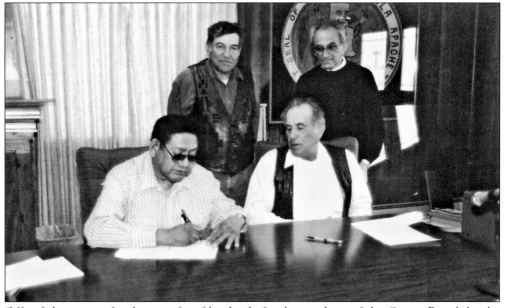

Official documents for the transfer of land title for the purchase of the Gomez Ranch by the Jicarilla Apache Nation were signed on March 28, 1996. In this photograph are, from left to right, (first row) Pres. Leonard Atole signing for the nation and Manuel Gomez; (second row) Mauricio Gomez and Monsignor Leo Gomez. (Courtesy of *Jicarilla Chieftain*.)

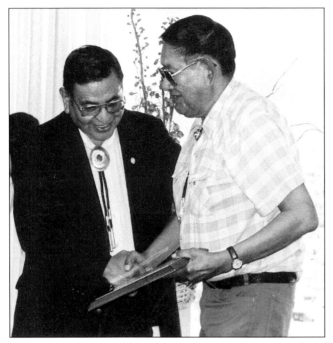

In May 1999, Pres. Leonard Atole (right) presents Councilman Hubert Velarde (left) with a certificate of appreciation for starting the water rights litigation 30 years before, when he was tribal president. The litigation was a 25-year process and resulted in the Jicarilla Apache Water Rights Settlement Act of 1992. (Courtesy of *Jicarilla Chieftain*.)

Wilhelmina "Wilma" Phone began work on the preservation of the Jicarilla Apache language in the late 1970s. She taught language classes, collected oral histories, and served as a mentor to other language teachers. Phone was one of the authors of the *Dictionary of the Jicarilla Apache* and was awarded an honorary doctorate from the University of New Mexico for her work. (Courtesy of *Jicarilla Chieftain*.)

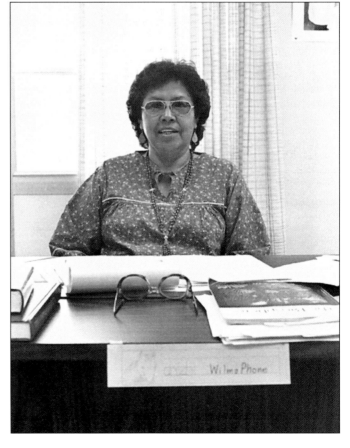

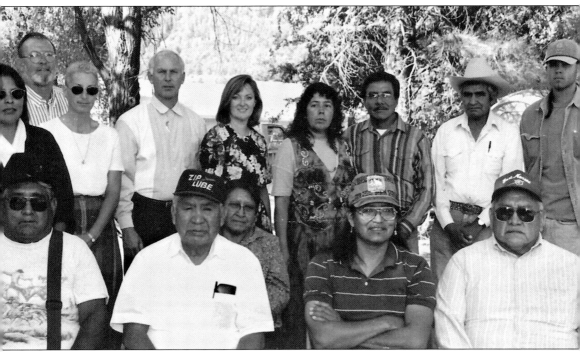

The Jicarilla Cultural Committee spends a lot of time conducting cultural consultations with federal and state agencies. This photograph shows the committee meeting with representatives from a state agency. From left to right are (first row) Jackson Velarde, Jonathan Wells, Iris Howe, Bryan Vigil, and Howard Vigil; (second row) Lorene Willis, four unidentified people, Aurora Cata, Steven Cata, Raymond Tafoya, and an unidentified person. (Courtesy of *Jicarilla Chieftain*.)

Giselle Quiver, daughter of Ingeborg Vicenti, was in the 32nd Annual Little Beaver Roundup infant and toddler contest for the traditional attire category when this photograph was taken. (Courtesy of Ingeborg Vicenti.)

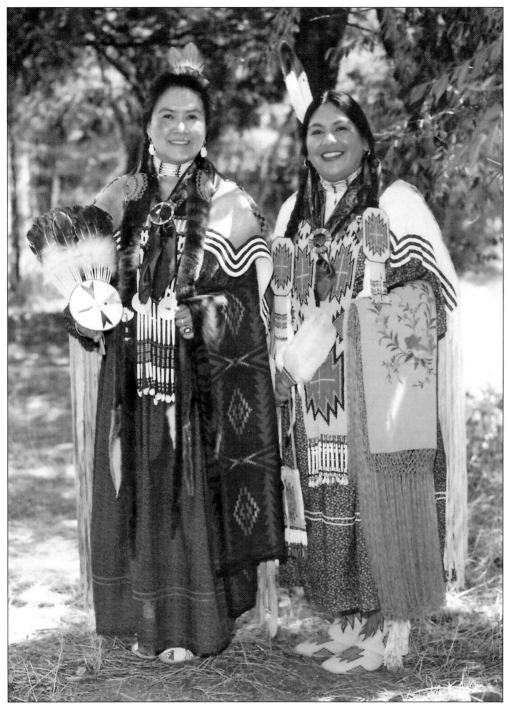

Vida Vigil and Ingeborg "Inky" Vicenti are examples of how Jicarilla women value both their traditional heritage and higher education. Vida is a 1978 graduate of the Institute of American Indian Arts. She also received her bachelor of arts in 1997 from the College of Santa Fe. Ingeborg received her bachelor's and master's degrees from the College of Santa Fe in the field of psychology in 1981 and 1996, respectively. (Courtesy of Images of David's Photography of Santa Fe.)

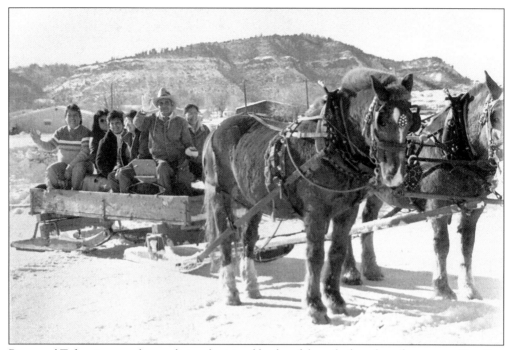

Raymond Tafoya is not only a traditional spiritual leader of the tribe but also a fun person. He offers team and wagon rides, mainly to children. In this photograph, he is giving a sleigh ride to adults. Raymond is seated in the front. Behind him from left to right are Faron Baltazar, Rose Debuta, Vurlene Notsinneh, Tinker Vicenti, and Bernadette Howland. (Courtesy of *Jicarilla Chieftain*.)

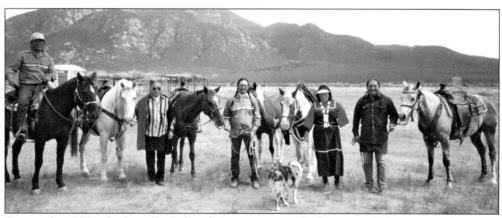

During the 1990s, the Jicarilla Cultural Committee reached out to tribal groups and national organizations to promote Native American cultural heritage. From left to right in this photograph, Taylor Monarco Jr., Gilbert Suazo, Bryan Vigil, Cultural Center director Lorene Willis, and Don Lightning Bow are on a horseback expedition to the Taos Pueblo Feast to re-enact a historic Jicarilla Dulce-to-Taos trip. (Courtesy of Jicarilla Apache Cultural Center.)

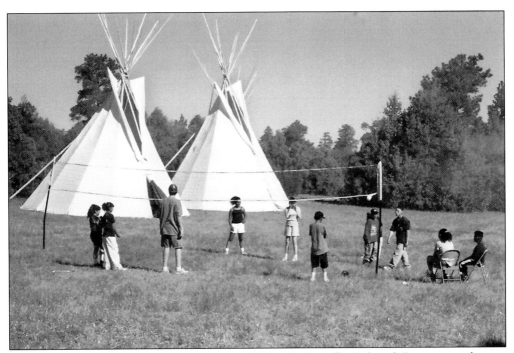

To promote Jicarilla culture throughout the 1990s, the Jicarilla Cultural Center staged many events for Jicarilla youth. At this summer youth camp, young children play volleyball near two tipis. (Courtesy of Jicarilla Apache Cultural Center.)

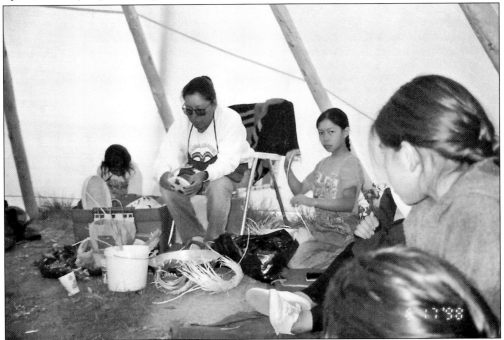

In this photograph, Melanie (seated at left) and Ann Pesata (right) are inside a tipi with several children teaching them willow basketmaking, a traditional art of the Jicarilla Apache, as part of the classes offered by the Jicarilla Cultural Center. (Courtesy of Jicarilla Apache Cultural Center.)

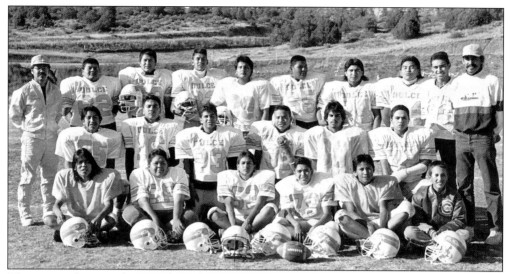

This group of teenage boys made up the Dulce High School Golden Hawks football team. They are pictured with two of their coaches at the school football field in Dulce. From left to right are (first row) unidentified player, Bryan Vicenti, three unidentified players, and Isley Cassador; (second row) unidentified player, Aberham Trujillo, Jose Maes, Alfred Redwine, Mercury Vicenti, and Francis Talamante; (third row) coach Eric Martinez, Theodore Loretto, Lorenzo TeCube, Cordell Vicenti, Fritz Burgess, Waymore Callado, Rudy Chavez, Alfred Vigil, Tommy Martinez, and assistant coach Carson Vicenti. (Courtesy of *Jicarilla Chieftain*.)

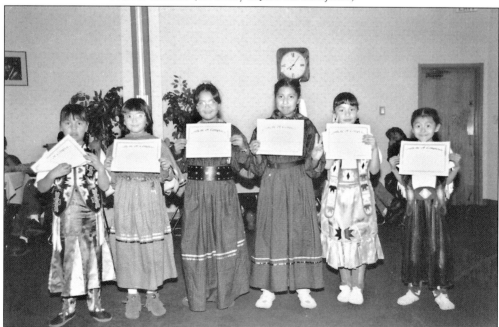

On December 31, 1999, the last day of the 20th century, the *Jicarilla Chieftain*, the official newspaper of the Jicarilla Apache Nation, recognized, from left to right, Tanisha Williams, Kayla DeDios, Patty DeDios, Autumn Dauke, Ashleigh Ortiz, and Quiana Vigil as participants in the traditional dress awards ceremony held at the Jicarilla Inn on December, 15, 1999. (Courtesy of *Jicarilla Chieftain*.)

It was common to see the Stone Lake Singers at community gatherings from school events to inaugural ceremonies and special occasions in off-reservation towns and cities. They are, from left to right, (first row) Matthew Vigil and Pat Notsinneh; (second row) Taylor Monarco Jr., Jay Paiz Sr., Carlos Lovato, and Shae Yeahquo. (Courtesy of Private Collection.)

In 1999, the Jicarilla Wildlife and Fisheries Management Program was an Honoring Nations Honoree, a nationwide program of the Harvard Project on American Indian Economic Development, for its environmental program for the management of its elk and mule deer population. The program operates and manages a 14,500-acre game park using state-of-the-art technology to preserve the tribe's wildlife population. (Courtesy of Jicarilla Game and Fish Department.)

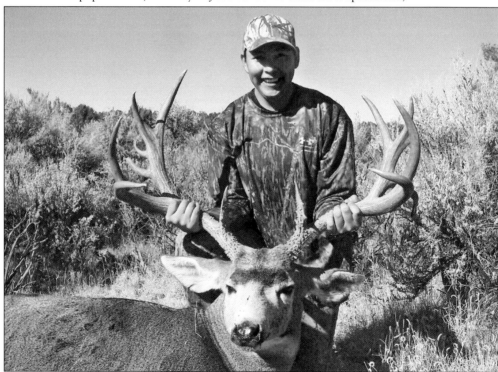

The Jicarilla Reservation has a reputation for producing more trophy mule deer than any other comparably sized area in North America. In this photograph, Vincent Tafoya is the happy deer hunter. (Courtesy of Jicarilla Game and Fish Department.)

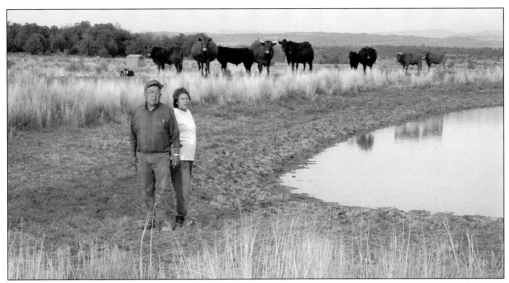

The livestock industry declined in the 1960s, but a handful of Jicarilla people continued in the business. A successful ranching operation on the southern end of the reservation is owned by Lindberg and Maxine Velarde. They use scientific methods in their cattle operation, rotating herds among cross-fenced pastures and utilizing the Savory grazing method to encourage growth of new grasses on fully stocked ranges. (Courtesy of Mary M. Velarde.)

Photographer Nancy Warren took this picture of three Ollero women in 1981 at Goijiya. Standing from left to right are Belle Wells, Ester Hassall, and Rebecca Martinez. Wells and Martinez have been part of this ceremonial event throughout their entire lives without fail. Hassall lives off the reservation, but that has never stopped her and her family from attending Goijiya. (Courtesy of Nancy Hunter Warren.)

According to Jicarilla Apache cultural ways, children are encouraged at a very early age to fully participate in tribal religious and social ceremonies. In this photograph, young boys who have participated in the Goijiya races are playing in front of the flagbearer as the Olleros and Llaneros come together down the racetrack. (Courtesy of *Jicarilla Chieftain*.)

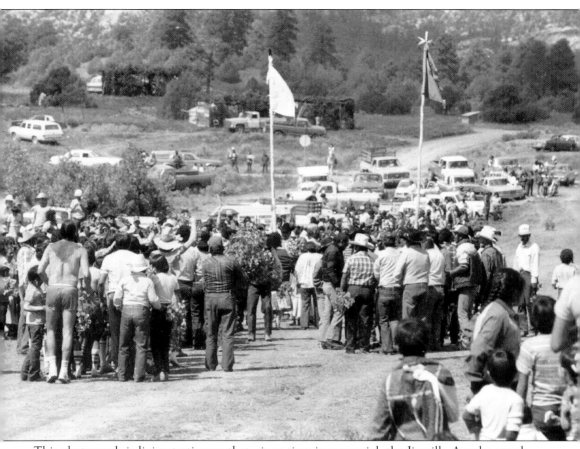

This photograph is living testimony that, since time immemorial, the Jicarilla Apache people have come together every year to celebrate Goijiya, the ceremonial relay races that take place between the two clans, the Llaneros and Olleros, commonly referred to as the "Red Side" and the "White Side." The days September 14 and 15 were chosen by the Jicarilla for the ceremony when they were relocated to the 1887 reservation. (Courtesy of Mary M. Velarde.)

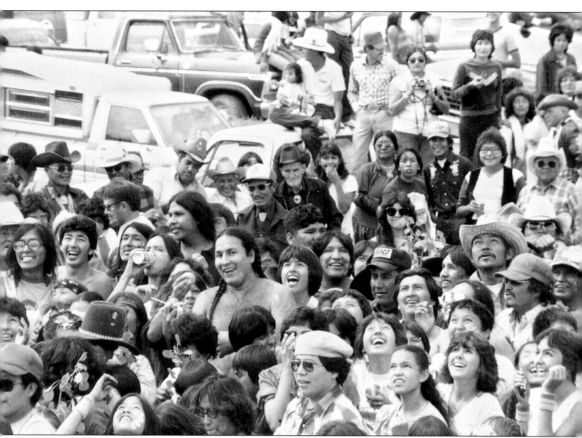

At Goijiya, as Jicarilla Apache people, we give thanks to our Creator, to Mother Earth for the bounty of the earth, for our good fortune and we pray for guidance in all areas of our lives the coming year. We believe that because we have kept our native religion and our Apache ways, we are the people we are today. May the Great Spirit continue to protect us and guide us into the next century. We give our gratitude for all that was given to us since 1887. (Courtesy of Mary M. Velarde.)